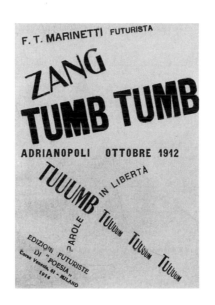

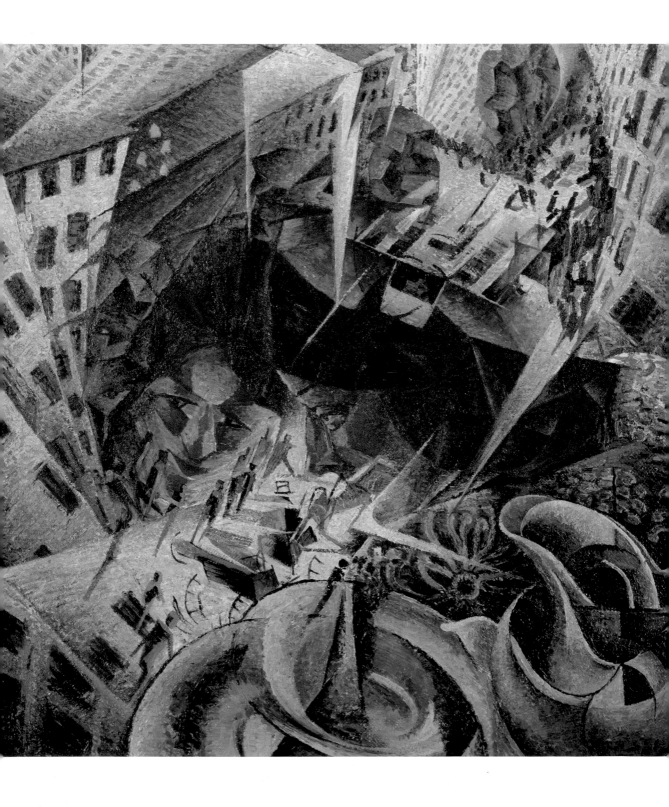

Futurism

SYLVIA MARTIN
UTA GROSENICK (ED.)

TASCHEN

KÖLN LONDON LOS ANGELES MADRID PARIS TOKYO

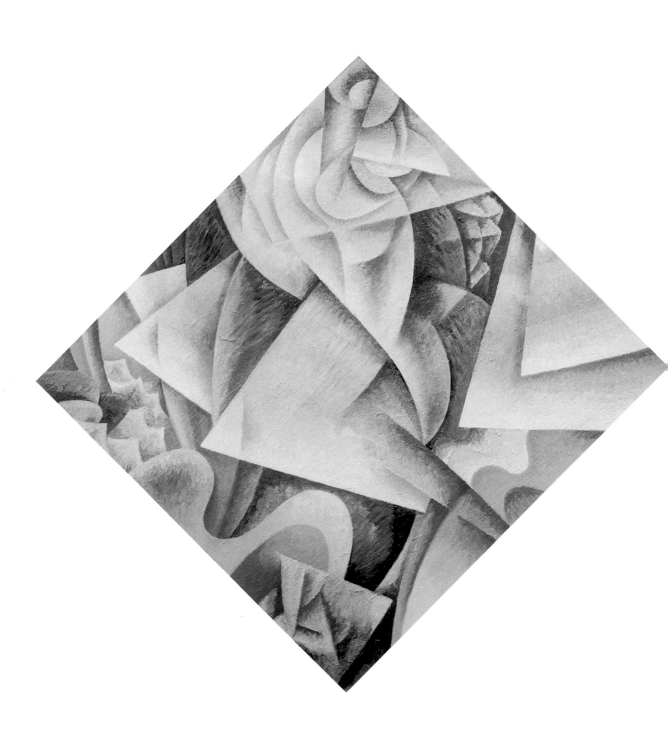

content

art + action + Life = Futurism

1. F. T. MARINETTI

<u>Founding Manifesto of Futurism</u>
"Le Figaro," 20 February 1909

2.

<u>The Futurists in Paris</u>
1912, from left to right: Luigi Russolo, Carlo Carrà,
F. T. Marinetti, Umberto Boccioni, Gino Severini
Private collection

The year 1909 marked a watershed in cultural developments in Italy. The traditions passed down from Greco-Roman antiquity and cultivated by art lovers throughout the world, and the notion of a perpetual Arcadia kept alive by travellers far down into the nineteenth century, had long grown stale in the country of their origin. Back in 1786, when Johann Wolfgang von Goethe arrived in Rome after a long and wearisome journey, he noted in his diary that there were so many treasures he could never own, but that, admired on site, would serve him "and others as guidance and furtherance for a lifetime." Even today, ancient Roman ruins convey an idea of classical styles and values to never-ending streams of tourists.

Yet the nineteenth century brought no innovations to Italy that might have infused fresh life into this culture which lived on the glory of the past. The country's rocky political, social and economic road to a unified modern nation in the latter half of the century, known as the Risorgimento, or Period of Rebirth, only helped to quash emancipatory tendencies. Even the vital, relaxed style of the Macchiaioli, or Patch Painters, which paralled the optimism of fledgling Italian nationalism, was little more than a derivative version of the French Impressionism that immediately preceded it.

mythical visions of a new world

Now came the great reckoning, a reorientation that swept Italy into the current of progressive streams in modern art, such as Expressionism and incipient Cubism. On 20 February 1909, with the publication of his manifesto "Le Futurisme" in the popular French journal "Le Figaro," Filippo Tommaso Marinetti founded the Futurist movement at one fell swoop. "I hesitated a moment," wrote Marinetti a few years later, "between dynamism and electricity. My Italian heart beat faster when my lips invented and loudly voiced the word Futurism. It was the new formula for art-action."

Over the next three decades many artists from diverse fields – literature, visual art, theatre, the crafts, music, photography – would unite under the banner of Futurism. The aim they shared in common was a renewal of life in every social and aesthetic respect, taking current technological achievements and scientific insights as the point of departure and standard for their ideas. As this indicates, Futurism was not just another avant-garde movement concerned solely with formal or aesthetic innovation, like, say, Cubism. Rather, it strove to exert a direct influence on life. This vision was pursued by highly diverse artist personalities, whose individualism enriched the movement but also made it prone to quarrels and divisions. The Futurist group proved flexible in

1895 — Wilhelm Konrad Roentgen discovers X-rays

1899 — First wireless telegraph message sent across the English Channel

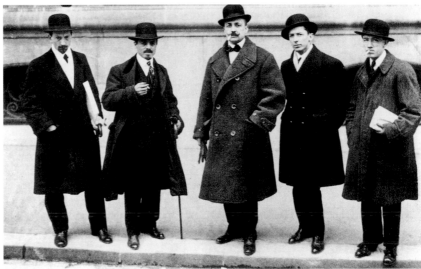

"Put simply, Futurism means hate of the past. Our aim is to energetically combat and destroy the cult of the past."

F. T. Marinetti

terms of membership, time and place, and went through many ups and downs before it finally lost momentum in the first half of the 1940s.

Marinetti was long the recognized leader of the movement. Born in 1876 in Alexandria, Egypt, he initially studied law before devoting himself entirely to literature and poetry. He felt just as much at home in his university city, Paris, as in Milan, where his family settled. There, in 1905, Marinetti founded a publishing house and eponymous journal, "Poesia," a forum for contemporary international poetry that would become the first printed organ of Futurism. With "La Voce," "Lacerba" and "Italia Futurista," all headquartered in Florence, followed further cultural journals. These, however, were not always unqualified supporters of Futurist doctrines.

Both in France and Italy, Marinetti went on lecture tours in which he recited Romantic and Symbolist French poets such as Charles Baudelaire, Stéphane Mallarmé, Arthur Rimbaud and Gustave Kahn. He gave early evidence of skills that would soon be sharply honed in the cause of Futurism: an incisive rhetoric in the spoken and written word, and a gift for exploiting mass communications media and a network of international contacts.

Marinetti's manifesto became a nucleus of dissemination on which almost every member of Futurism relied. As *spiritus rector*, Marinetti set the standards. For his article of 20 February 1909 he employed the linguistic form of the manifesto, that is, a broadside proclamation addressed to the public at large. Without bothering to analyze the cultural and social situation in Italy, Marinetti proclaimed a new state of affairs and a new view of the world, contained in eleven points. To quote only four of these:

1. "We shall sing the love of danger, of habitual energy and daring …"

4. "We declare that the glory of the world has been enriched by a new beauty: the beauty of speed …"

7. "There is beauty only in struggle. No masterpiece without an aggressive aspect …"

9. "We shall glorify war – that sole hygiene for the world – militarism, patriotism, the destructive deeds of the anarchists, the great ideas one dies for, and a disdain of woman …"

By employing the manifesto form, the communications strategist Marinetti hoped to bridge the gap between artists and art on the one hand, and their audiences on the other, a gap that in the nineteenth century had widened to the point of general mutual alienation.

In verbal salvoes that reflected absolute certainty, Marinetti proceeded to overthrow every past tradition. Museums and libraries, places of collecting and preservation, must be destroyed, he declared. "Museums, churchyards!" were one and the same for him. *Passatisme*,

1901 — Roentgen receives Nobel Prize in Physics
1902 — Racing cars reach a top speed of 100 km/h
1905 — The Voisin Brothers commence building aircraft in Paris

"A roaring motorcar is more beautiful than the Nike of samothrace."

F. T. Marinetti

3

that obsession with the past that signified everything backward about Italy, would be supplanted by Futurism. The artists carried this catchword before them like the ensign of an advancing army. Futurism stood for an unqualified glorification of technology, speed and vital life within a social structure revolutionized by industrialism. The automobile – Marinetti thought racing cars lovelier than the Nike of Samothrace – streetcars, telephones, aeroplanes and railway networks were technical advances that since the late nineteenth century had altered not only the look of cities but people's conception of the world. Distances shrunk, perspectives were foreshortened or shifted, the entire world seemed caught up in accelerated motion.

In Marinetti's eyes, the products of the industrial revolution embodied the promise of a new model of life. He raised them to fetishes of an attitude fueled by violence and rebellion, a revolutionary impetus that to him symbolized the future. Yet with the first Futurist Manifesto, this overthrower of mythology and ideals provided just that – a new founding myth. His followers, Marinetti declared, would become aware during a sleepless night of their technological environment, whose noises and smells would penetrate into their homes. "As we were listening to the dissipated prayer of the canal and the grinding of the skeletons of the moribund palaces in their beard of green, the hungry automobiles suddenly began roaring under our window."

His friends would step out into the city streets, and go "… over to the three snorting beasts, to lovingly caress their hot breasts." Mounting these beasts – i.e. cars – they would begin a careening ride through the city which finally ended in a ditch. "Oh, maternal ditch, filled nearly to the brink with filthy water! Oh, lovely drainage ditch of a factory!" Driver and car would rise from the mire as if reborn and vitally animated despite their bruises. Then they would recite the eleven points mentioned and launch into a swan song for old, doomed Italy.

For all his glorification of the latest technological advances, Marinetti was not interested in actual labour and production conditions like those found especially in northern Italian factories. Human beings as pawns in the game of industrial expansion or as helpless victims of social inequality played no role for him. Instead, in his novel "Mafarka-Le-Futuriste, Roman africain," published in 1910, Marinetti drew a picture of a "superman," a subjective correspondence to the objective world of technology – a hybrid man-machine. This titan, conceived without the aid of woman, was untroubled by sentimental memories. He lived solely in and for the moment, unleashing his vitality and destructive power without mercy or pangs of conscience.

In its radical plea for renewal, its Promethean force and compelling polemics, Marinetti's mythical vision of a new world clearly recalled Friedrich Nietzsche's philosophical prose-poem "Thus Spake

1908 — Wilhelm Worringer publishes "Abstraktion und Einfühlung, ein Beitrag zur Stilpsychologie" (Abstraction and Empathy, a Contribution to the Psychology of Style) 1909 — Louis Blériot becomes the first man to cross the English Channel in an aeroplane

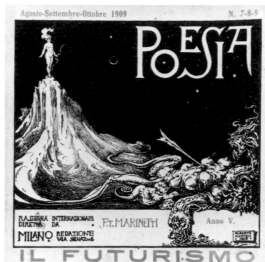

4

5

Zarathustra," which appeared between 1883 and 1885 and became obligatory reading for uncounted artists around and after the turn of the century. Nietzsche's character Zarathustra predicted a coming "superman," who would supplant the comfort-loving and therefore futureless men and women of the day. Like Marinetti, Nietzsche attacked hidebound bourgeois values and excepted from his critique almost no area, whether church or state, literature or science.

Marinetti's novel "Mafarka-Le-Futuriste" had a great impact, as indicated by the literary show trial undertaken against its author in Milan before its year of publication, 1910, was out. The charge was an offence against morals and propriety. Even though Marinetti, who spoke in his own defense, was ultimately acquitted, the case illustrated two key points: first, the discrepancy between the revitalizing visions of the Futurists and the accepted values of Italian bourgeois society; and second, the possibility of using a public spectacle to disseminate Futurist ideas in a highly effective way.

Provocation and uproar as effective publicity for art

On 12 January 1910, in advance of Marinetti's show trial, the first *serata futurista,* or Futurist soirée, took place at the Politeama Rossetti, the Municipal Theater of Trieste. These soirées, frequently organized ad hoc by Futurist artists at various venues, had differing agendas. They extended from recitals of poetry and manifestoes to musical performances, but these merely formed a framework for art-actions aimed at provocation and uproar. By histrionically declaiming their texts or inciting the audience "not to applaud but to boo us off the stage," the Futurists again and again challenged the audience to interaction. They purposely aimed at creating a state of emergency, as it were, in which members of the audience would become actors, and lawlessness and vital chaos reigned. Scandal was their express aim, and they relied on the ensuing press reports to spread their brand of anarchy among the respectable citizenry.

The first evening, on 12 January, went off rather uneventfully. In Milan, center of Futurism until 1915–16 and scene of the second *serata futurista,* audience reactions were much more indignant. The event was announced by brief notices in the daily papers, posters and through the artists' grapevine. Held at the Teatro Lirico on 15 February 1910, the soirée spun completely out of control. Apart from an explanation of Futurist aims and a reading of the founding manifesto and poetry, an anti-Austrian debate of the kind then virulent in Italy triggered tumultuous reactions. Fueled by provocative Futurist slogans and interruptions and catcalls from the audience, the situation

--
1911 — Italy goes to war with Turkey in Libya 1911 — Revolution in China
 1911 — Wassily Kandinsky publishes his treatise on art theory, "Über das Geistige in der Kunst" (On the Spiritual in Art)
--

"ʙᴀttle: weight and smell midday 3/4 flutes groans redhot boom-boom alarm ɢargaresh crashing rattling march clatter/backpack guns hooves spikes cannons manes wheels boxes jews fritters oilcake cantilena/general store fumes scintillations eyedrippings stench cinnamon/ᴍould ebb and flow pepper fistfights dirt eddying blossoming – orange tree filigree misery/dice chess-men cards jasmine + nutmeg + rose arabesque mosaic carrion thorns bungling…"

F. T. Marinetti

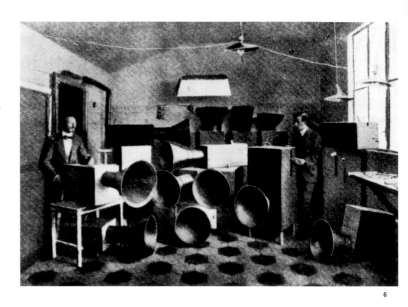

6

escalated to the point of fistfighting, which only two police officers on the premises were able to quell. Although the artists had to cut short the event in the theatre, the tumult continued outside on the streets for some time.

For the Futurists, the event was a perfectly staged scandal. Young Italian artists began to obtain increasing attention from the media, which inadvertantly disseminated their new ideas. In part they could look back in this regard on experiences and strategies from the nineteenth century. A famous instance was the attention garnered by Gustave Courbet when he showed his painting *The Bathers (Les baigneuses)* at the 1853 annual Paris Salon. The subject, two nude women in the woods, stripped of all mythological or allegorical trappings, profoundly shocked the audiences of the day. The Futurists proceeded to expand such incidents into radical artistic strategies.

The Futurist soirées – many of which were held in larger Italian cities until the end of 1915 – were not only highly significant as an anarchistic forum but provided an important platform for artists and writers who had no other opportunity to show or publish their work. Luigi Russolo, for instance, who after beginnings in music went on to study painting, was able to present his *intonarumori,* or noisemaking instruments, at the soirée held on 21 April 1914 in the Teatro dal Verme in Milan. This had been preceded by a manifesto, "The Art of

Noises" (L'art des bruits), dated 11 March 1913, which Russolo had sent in the form of a letter to his Futurist colleague, the composer Francesco Balilla Pratella. Russolo's instruments consisted of large crates mounted with amplifying trumpets, some operated by so-called "accumulators," which produced a diversity of sounds and noises. They hummed, rattled, rumbled, whistled, howled and hissed – in short, brought the acoustic world of technology and industry into the concert hall. Such acoustic material drawn from the real environment would subsequently be employed by *Musique concrète* in the late 1940s. At the 1914 soirée in Milan, the music-and-art activity ended in a chaotic mêlée in which Futurists, audience and police went at each other's throats.

the ꜰuturist ᴘainters

The painter Umberto Boccioni had his first taste of the Futurist movement on 15 February 1910, as an onlooker at the soirée at the Teatro Lirico in Milan. Fascinated by Marinetti, Boccioni joined the group together with his friends Carlo Carrà and Luigi Russolo. These artists, whose works crucially shaped the look of Futurism, have remained unmentioned to this point because the movement was initi-

--

1911/12 — Pittura metafisica, or Metaphysical Painting, established by Giorgio de Chirico, Carlo Carrà and Giorgio Morandi

1912 — Universal suffrage introduced in Italy

--

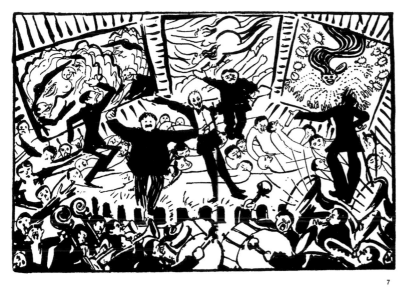

6.

<u>Workshop for "intonarumori" in Milan</u>

7. UMBERTO BOCCIONI

<u>Serata futurista (Futurist soirée)</u>
Milan, 1911, from left to right: Umberto
Boccioni, Francesco Balilla Pratella, F. T.
Marinetti, Carlo Carrà, Luigi Russolo; in
the background: paintings by Boccioni,
Carrà and Russolo
Private collection

7

ated solely by Marinetti's manifesto and the proclamations of Futurist ideas he co-authored with literary friends. At that point in 1909, no aesthetic correspondence yet existed in any of the fields of art the Futurists would later so fruitfully employ. Even literature, Marinetti's own field, showed few innovations in style or content at that time. The tone in fin de siècle Italy was set by the author and playwright Gabriele d'Annunzio, with symbolically charged writings that were beholding to the Greco-Roman ideal of beauty. His sentimental plays still drew sustenance from the inspiring atmosphere of the Risorgimento.

The protagonists of Futurism in the visual arts had before they became Futurists few points of contact. Boccioni, the key Futurist figure alongside Marinetti, moved to Milan in 1907. Prior to that he and Gino Severini had taken instruction from Giacomo Balla in Rome. At this period Balla was interested in the labour milieu and the progress of civilization, subjects of which the expanding metropolis provided ample illustrations. His painting *The Day of the Labourer (La giornata dell'operaio)*, 1904, evoked proletarian reality in the shape of a house under construction. The artist fragmented the scene into different perspectives and situations, already approaching very closely one of the essential aesthetic devices of Futurism, the simultaneous representation of diverse sense impressions. Later, the act of house-building would become a Futurist synonym for creativity per se.

In Milan, Boccioni adopted this form of socially motivated realism. In addition to a few sensitive self-portraits he painted *Factories at the Porta Romana (Officine a Porta Romana)*, a snapshot of the prospering industry on the periphery of Milan. With rapid industrial growth in Milan, Turin and other northern cities and a neglect of the crisis-shaken agricultural south, the young Italian nation stood on insecure footing. The economic boom, which should have prompted an adequate social welfare policy, collided with hidebound power structures, and their negligence was answered by unrest, strikes and repression. Milan was a key focus of unrest, and Boccioni, along with Carlo Carrà and Luigi Russolo, who had likewise settled there, were caught up in the events. Carrà befriended socialists and anarchists, and immersed himself in the writings of Karl Marx; Russolo frequented literary circles and early on began writing articles for Marinetti's journal "Poesia." Gino Severini, on the other hand, lived from 1906 principally in Paris, thus establishing contacts between the Milan Futurists and the pulsating cultural capital of Europe. His imagery centred around classical Parisian subjects – theatre, dancers, and naturally the Montmartre district, where artists gathered in cafés to exchange views.

On 11 February 1910, these five artists – Balla, Boccioni, Carrà, Russolo and Severini – signed the "Manifesto dei pittori futuristi"

1913 — Sigmund Freud publishes "Totem and Taboo"
1914 — The assassination of Archduke Franz Ferdinand of Austria and his wife Sophie in Sarajevo touches off World War I

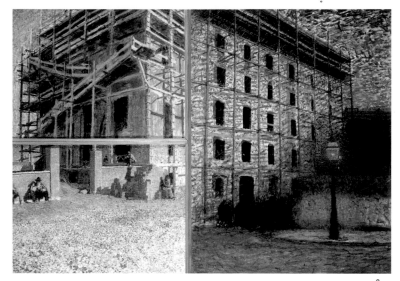

8

(Manifesto of Futurist Painters) and proceeded to take Futurist art to its first culmination. This creative surge would last until 1915, when a grave caesura altered the composition of the group.

manifestos of Futurist painting

In its pathos and rigorous rejection of all traditions, the Futurist painters' first manifesto echoed Marinetti's first proclamation: "Comrades! We hereby declare to you that the triumphant progress of science has caused such great changes in humanity that an abyss has opened between the obsequious slaves of the past and us free men who are certain of the radiant glory of the future." The art system was accused of corruption and lethargy across the board, and only three painters in Italian history, a generation older than the writers and ignored by the critics – Giovanni Segantini, Gaetano Previati and Medardo Rosso – were accepted as ideals. Once again, protagonists of Futurism defined their position primarily in negative terms. Of the eight proclaimed principles, only the last vaguely stated a positive aesthetic aim: "To represent and glorify contemporary life, which triumphant science is incessantly and tempestuously changing."

The motifs of progress and its effects were easily identified: the automobile, the aeroplane, electric lighting, building construction, the hectic pace of life and demonstrations in the streets. Yet how could these signs and scenes be brought into conformance with the Futurists' new sense of life and translated into forms and colours on canvas? In this regard all of the artists involved had initial difficulties. During this phase when expectations and practice still greatly diverged, Boccioni admitted, "The obligation we have assumed is terrible, and the visual means appear and disappear the moment we try to put them into practice." The painters adopted familiar formal elements from Impressionism, Divisionism and even Symbolism. They experimented with the expressiveness of line, divided their motifs into countless dots of paint, or dissolved them in a flood of light.

At the same time, they intensified their search for new, adequate means of representation in theory as well. As early as 11 April 1910 they published a second manifesto, the "Technical Manifesto of Futurist Painting." As the title indicates, their notions of Futurist imagery had now become somewhat more concrete. They spoke of complementary contrasts, the employment of red-blue, green-orange, violet-yellow as an absolute prerequisite for modern painting, and noted how movement and light appeared to "destroy" solid bodies, thus paving the way for a representation of "dynamism."

1914 — "Dubliners," a book of short stories by James Joyce, appears in England 1915 – 23 May: Italy declares war on Austro-Hungary
1915 — Benito Mussolini founds the newspaper "Il Popolo d'Italia" in Milan

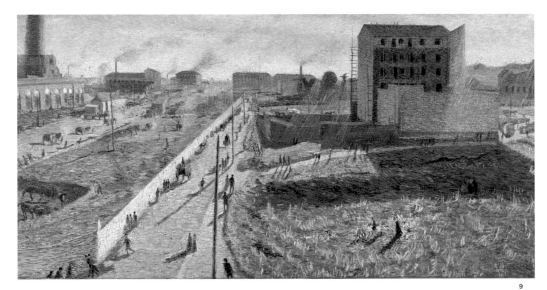

9

"NOW we are satiated [with traditional music] and we find far more enjoyment in the combination of noises of trams, backfiring motors, carriages and bawling crowds than in rehearsing, for example, the 'EROICA' or the 'PASTORAL.'... we enjoy creating mental orchestrations... of din, from stations, railways, iron foundries, spinning wheels, printing works, electric power stations and underground railways. NOR should the newest noises of modern war be forgotten."

Luigi Russolo

The Italian Futurists publicly showed their works for the first time in spring 1911, at a self-organized, unjuried exhibition titled "Mostra d'Arte Libera" (Exhibition of Liberated Art) in Milan. Severini, who had signed the manifestos but was not yet familiar with his confreres' paintings, immediately realized that they lagged behind the latest developments in Paris. In autumn 1911, Marinetti, the only one in the group from a well-off background, financed a trip to Paris for Boccioni, Carrà and Russolo. There they were confronted with the beginnings of Cubism in the art of Pablo Picasso and Georges Braque, as well as with Robert Delaunay's paintings of the Eiffel Tower.

At about this point in time, familiar perspectives on the world went out of joint in many places at once. Habitual processes of perception were put to the test. Artists were now no longer satisfied with naturalistically depicting slices of the visible world, especially as scientific insights had shown that it consisted of more than optical appearances alone. In the analytic phase of Cubism, from 1909/10 to 1912, Picasso, Braque and their allies attempted to represent different points of view by fragmenting objects and figures and merging them with the surrounding space. The facetted, brownish-gray picture plane now offered two types of legible information: the motif itself and a conceptual understanding of space.

The Futurists profited as much from the formal aesthetics of Cubism as from the other styles – Divisionism, Impressionism, Orphism, Expressionism – on which they relied. The presence of familiar stylistic elements in their pictures led to accusations of eclecticism, yet at the same time, the Futurists' appropriations seemed to anticipate the postmodernist approach. The resulting contradiction between avant-garde claims and dependency on earlier styles remains unresolved.

The painters made great efforts to perfect their visual means and bring them into conformance with the new Futurist world view, according to which everything was in dynamic motion and charged with energy. Unlike the Cubists, who defined an unconventional perceptual approach largely by reference to static objects, the Italians, with their faith in progress, attempted to visualize a universal model of movement. Yet the Futurist painters arrived at quite different pictorial strategies despite their common aims. Giacomo Balla's depictions of physical sequences of motion marked the one pole, and Boccioni's visualization of the essence of motion the other. Russolo, Carrà and Severini worked between these two extremes, each arriving at an individual mixture of solutions. Except for Russolo, who finally turned to music, these artists remained true to the painting medium; that is, they never tired of attempting to fix dynamic effects on a static sur-

1916 — Hugo Ball founds the Dada Cabaret Voltaire in Zurich

1916 — Rosa Luxemburg and Karl Liebknecht establish the socialist Spartacus League

10. CARLO CARRÀ

Horse and Rider
1912, oil on canvas, no measurements given
Milan, Civico Museo d'Arte Contemporanea,
Palazzo Reale

11. ETIENNE-JULES MAREY

Chronophotograph (detail)
1886

12. ANTON GIULIO BRAGAGLIA

Photodynamism
1913

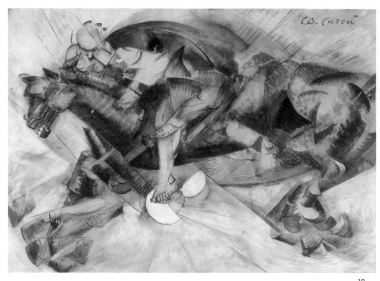

10

face, the canvas. As this implies, Futurism remained limited to an evocation of movement, comparable to that long before achieved by the nineteenth-century English artist William Turner, in his *Rain, Steam and Speed – The Great Western Railway.* Moreover, Boccioni's sculptural experiments never truly conveyed a realistic impression of movement.

Dynamism and simultaneity

Futurist art theory was dominated by two categories: dynamism and simultaneity. These are interrelated concepts and very difficult to consider in isolation. As regards both terminology and content, the Futurists relied strongly on the writings of the Frenchman Henri Bergson (1859–1941), whose vitalistic philosophy exerted a great influence not only on Italian artists. Bergson's notion of reality as being continually in the process of becoming, summed up in the concept of *élan vital,* was a source of inspiration or confirmation for many artists of the period.

In the "Technical Manifesto of Futurist Painting," dynamism is described by reference to scenes in motion. "Thus a galloping horse does not have four but twenty legs, and their movements are triangu-

lar." Then the authors explain, "The sixteen people around you in a moving streetcar are one, ten, four, three: They stand still, and they move; they come and go, they rebound, consumed by a zone of sunlight, back onto the street, then they return to their seats, persistent symbols of universal vibrations."

Boccioni defined these examples more precisely in his 1914 book "Pittura scultura futuriste (Dinamismo plastico)" (Futurist Painting and Sculpture [Pictorial Dynamism]). Here he distinguished between an "absolute motion," implying the intrinsic motion of objects as well as the realm of emotive feelings, and the "relative motion" generated by a moving object in relation to its moving or static environment. For the Futurists, reality was composed of these two forms of movement, which together added up to "universal dynamism."

In the practice of painting, subject matter now began to be dissolved by breaking open its forms and repeating certain elements. Passages of colour and abstract, dynamic lines derived from the subject served to interlock figure and ground. "Lines of force," the Futurist term for dynamic vectors of paint, animated the composition as much as the pure, brilliant colour values used, whose "virginity" and "rawness" corresponded to the Futurists' revolutionary mood. Not a few of their works were accordingly based on an aggressive red-blue contrast.

1916 — Albert Einstein's "General Theory of Relativity" is published in Germany 1917 — October Revolution in Russia
1917 — Theo van Doesburg and Piet Mondrian found the group and journal "De Stijl" in Holland

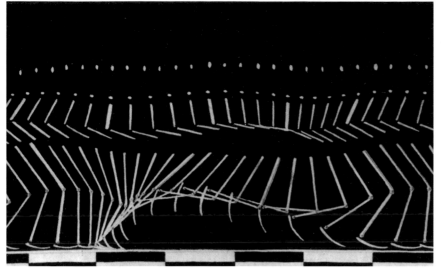

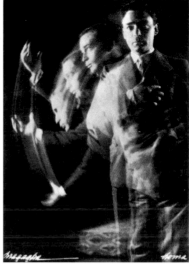

11

12

"we will have completely achieved our artistic intention when movement is a purely dynamic sense perception for us..."

Anton Giulio Bragaglia

Futurist Photography and Architecture

The division of a motion into its separate phases was something that had concerned Eadweard Muybridge in the United States and Etienne-Jules Marey in France back in the late nineteenth century. Using different methods, both analyzed motion sequences with the aid of photography. While Muybridge used several cameras to successively record a process of motion, Marey relied on only a single, specially developed "photo gun." His chronophotographs especially impressed Balla, who visited the hall at the 1900 Paris World Exposition where Marey's photographs were displayed. Yet most of the day's photography was not scientific in nature but reflected artistic ambitions. Usually limping behind painting, photographers exploited its aesthetic strategies to the point of plagiarism.

It was not until the second decade of the century that signs of a change appeared. In 1911, the brothers and amateur photographers Anton Giulio and Arturo Bragaglia published "Fotodinamismo futurista." Aware of Marey's chronophotographs and the Futurist approach to art, the Bragaglias envisioned a dynamic photography in which physical gestures would be captured as coherent movements in space. Multiple exposures, long exposure times and other technical devices resulted in blurred, out-of-focus imagery which the two

authors viewed as an independent, artistic and photographic correspondence to the dynamism of Futurism. Although Marinetti was open to such developments in photography, as well as to parallel ones in film, Boccioni, uncharacteristically cleaving to a traditional definition of art, rejected the new techniques as being unartistic, purely mechanical methods of reproduction. As a result, photography was initially excluded from the nucleus of the Futurist movement. Not until the second phase of Futurism would it be recognized as an artistic medium in its own right.

The situation was different in architecture and the public space shaped by it. If writers and artists were inspired in their futuristic considerations by the contemporary cityscape with its flourishing industrial zones, increasing traffic and pulsating life on the streets, architects such as Virgilio Marchi, Mario Chiattone and, foremost, Antonio Sant'Elia translated this universal dynamism into built superlatives. Exciting designs for the key architectural tasks of modern society emerged: houses, railway stations, power plants, airports. This renewal of architecture culminated in the vision of a city in which tall, narrow skyscrapers projected vertically into the air, surrounded by an encompassing, dynamic network of traffic arteries on several horizontal levels. Both the design of individual buildings and the entire urban area transformed the city into a pulsating organism that not only re-

1918 — End of First World War; founding of Weimar Republic in Germany

1918 — In Rome, artist and art critic Mario Broglio founds the journal "Valori Plastici," which will be published until 1922

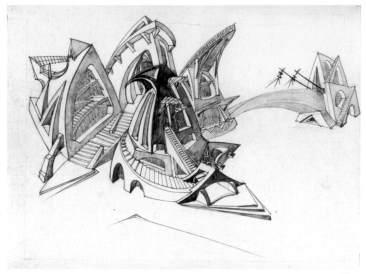

> **"we shall sing of the great crowds of people who are exhiliarated by labour, pleasure or revolt; we shall sing of the multi-coloured, multivoiced flood of revolutions in modern capitals."**
>
> F. T. Marinetti

13

flected the vitality of society but potentiated the phenomena of motion and speed.

Models for these ideas were provided especially by the interurban train system in Vienna, built on a series of traffic levels by Otto Wagner in the late nineteenth century. The Paris Metro and London Underground, and the skylines of New York and Chicago, likewise attested to the expansive, dynamic acceleration which had already been translated into reality in these proliferating urban centres. Yet the Futurist building designs and urban plans were never to be put into practice. They remained on paper, being visions that surpassed the limits of feasibility. Take the demand made by Sant'Elia in his 1914 manifesto "L'architettura futurista": "Buildings will have a shorter life expectancy than we ourselves have. Every generation will have to build its own city." Although the architect's premise of a permanent renewal conformed with Futurist aims, in practice it made his projects unrealizable.

The viewer is in the picture

The phenomenon of simultaneity, which was being discussed and applied by the Cubists and Orphists at the time, became a key part of the Futurist aesthetic around 1912. Building on dynamism, it implied the concurrence in time of various different events and their crystallization in a work of art. The concept of simultaneity was understood by the Futurists in a very general way, to include visual and emotional perception as well as memories and associations of thoughts and feelings. In Boccioni's view, simultaneity represented the basis of Futurist sensibility and the consequence of universal dynamism. This implied not only representing the life and bustle on the big-city streets in all their visual variety, but evoking the noises, smells, remembered happenings and the emotions they triggered to produce an atmospheric unity. Boccioni's *Simultaneous Visions (Visioni simultanee)*, 1911, shows a street scene as viewed through the eyes of a woman at a window. The excerpt is fragmented into facets and various perspectives, figures are doubled, the palette is aggressive and unnaturalistic. The viewer is invited to identify with the figure represented from the back at the extreme edge of the picture, and plunge, with her, into the visual and sensory experience. The Futurists even provided instructions for viewing, explaining "We place the viewer right in the midst of the picture."

The *parole in libertà,* or liberated words, with which Marinetti began expanding the possibilities of literature and poetry in 1912, worked in an analogous way. He first amplified the dynamics of language by stringing together nouns and infinitives, avoiding adjectives and adverbs, and replacing punctuation by the mathematical symbols

1918 — Kurt Schwitters proclaims "Merzkunst," or Merz Art, a nonsense name derived from an advertising sign of the Commerzbank
1919 — In Milan, Mussolini calls the fascist movement ("Fasci di Combattimento") into being

13. VIRGILIO MARCHI

<u>Architectural project</u>
1919–20, watercolour and pencil on paper,
no measurements given
Private collection

14. ANTONIO SANT'ELIA

<u>The New City</u>
1913, ink, pencil and watercolour on paper,
29.2 x 20.3 cm
Private collection

15. MARIO CHIATTONE

<u>Construction for a Modern Metropolis</u>
1914, watercolour and Chinese ink on paper,
106 x 95 cm
Pisa, Art Historical Institute of the University

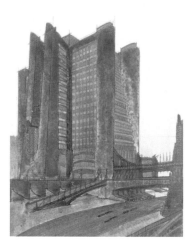

14

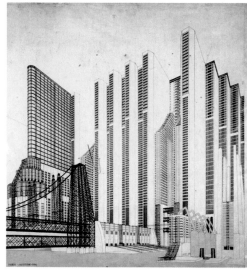

15

+, −, =, : , <, >. The first-person narrator vanished and the sound of the words unfolded dynamically and actively in telegram style. This staccato addition of words that precluded any syntactical flux could be charged with various levels of perception and sensation simultaneously. Each word was forcefully set, like an incarnation of sheer power – as Aldous Huxley once aptly described in a Futurist sense in his *Brave New World,* where he compared words to X-rays which, if rightly used, could penetrate anything.

The speechmaker and provocateur Marinetti created onomatopoetic montages and, with his *tavole parolibere,* liberated the typographical appearance of words as well. The traditional sequence of sentences in columns was replaced by visual texts in which words, letters, and symbols danced freely across the page to unfold a visual poetry. On these sheets, the device of simultaneity was employed to great effect, in terms of both form and content.

Transnational painting

From its first publication in a French journal, Futurism aimed at an international audience. Its protagonists, Marinetti foremost, carried the movement's message with typical actionism to the cultural centres of Europe. By 1912 at the latest, with the great travelling exhibition that included major works by Balla, Boccioni, Carrà, Russolo, Severini and Soffici, the Futurist agenda stood at the focus of debates on avant-garde rankings and approaches to the theory of perception. The presentation was organized in Paris by Severini in conjunction with the critic Félix Fénéon.

The travelling exhibition began in February 1912 at Galerie Bernheim-Jeune. In the accompanying catalogue the Futurist painters provocatively proclaimed, "With us, a new epoch in painting begins." They characterized Cubism, which was then in transition to its synthetic phase, as a brand of academic art that still cleaved to traditional subject matter. In view of the overweening position of modern French art, just reaching a new culmination in the work of Picasso and Braque, Delaunay and Fernand Léger, the Futurists' claim was like a slap in the face. Yet the affront was necessary to garner attention among the rival avant-gardes. This claim to pre-eminence was repeated in the catalogue to the Berlin show of Futurism, held at Der Sturm gallery in April 1912: "We stand at the spearhead of the movement of European painting." Such statements quintessentially reflected the Futurists' arrogance. At the same time, their paintings embodied the seriousness of their claims. In view of this ambivalence, the entire continent oscillated between reactions of indignation

1920 — Berlin Dadaists hold the "First International Dada Fair"
1921 — Mussolini's supporters establish a political party, "Partito Nazionale Fascista" (PNF)

"No fear is more stupid than that which makes us fear to transgress the field of art we practice. There is no painting, sculpture, music, poetry. There is only creation."

Umberto Boccioni

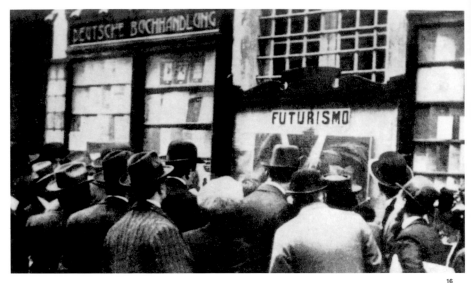

16

and rejection on the one hand, and approval and emulation on the other.

In Paris, Robert Delaunay vehemently denied the Futurists' claims. In his view, the principle of simultaneity had been realized first in contemporary French painting. Unlike Delaunay, Picasso showed no interest in debating the topic. In Berlin, Herwarth Walden offered the Futurists a dual platform: an exhibition at his Der Sturm gallery and publication of their articles in his eponymous journal. One of these was Boccioni's "Simultanéité futuriste," a text in which he attempted to refute Delaunay. The French artist in turn would be represented at the Berlin Autumn Salon of 1913, likewise organized by Walden, with numerous paintings that attracted the critics' full attention.

The first Futurist show at Der Sturm in 1912 was acquired to a large extent by a Berlin banker by the name of Albert Borchardt, and subsequently presented under Walden's aegis in various German cities, including Cologne and Munich. Wassily Kandinsky, co-founder with Franz Marc of Der Blaue Reiter in 1911, tended, unlike Marc, to view the Futurist movement with skepticism. Marc wrote to Kandinsky on 23 October 1912: "Just a brief note; [about] things that may interest you, e. g., that I saw the Futurists in Cologne and am unreservedly excited about the larger part of the paintings (especially Carrà, Boccioni, and Severini, too, in their more mature things); I hope this won't

anger you … They are brilliant painters; naturally impressionists; very stringent naturalism; not the ideas of the Bl.[auer] Reiter and that which you view as coming …"

Marc's statements reflected a general interest in Futurism on the part of the young, avant-garde generation. This interest was cogently summed up by Alfred Döblin, who wrote in the journal "Der Sturm" in 1912: "With a shrug the Futurist makes room for himself, casts the nightmare off his chest." Nevertheless, few if any artists in Germany, or elsewhere, felt the urge to convert to the Futurist religion of life.

Intensive contacts were made in England. In 1910 Marinetti introduced Futurism to London in lectures at the Lyceum Club for Women, followed in 1912 by the second stop of the great Futurist travelling exhibition, at the Sackville Gallery – to name only two events. A short time later, in 1914, a few British artists including Percy Wyndham Lewis, Lawrence Atkinson, David Bomberg, along with the poet Ezra Pound, developed an approach that likewise took its cue from industrial advance and the vitality of the big city. The group, which would exist for only two years, formed under the metaphorical title of Vorticism. To them the vortex and its rushing rhythm were an apt symbol of the pulsating age. Yet rather than viewing modern progress in terms of the speed of motorcars or airplanes, the Vorticists focussed on the functional structures and intrinsic organism of

1922 — 2 October: The fascists march on Rome. 31 October: Mussolini is appointed minister president of Italy
1924 — "First Manifesto of Surrealism," by André Breton

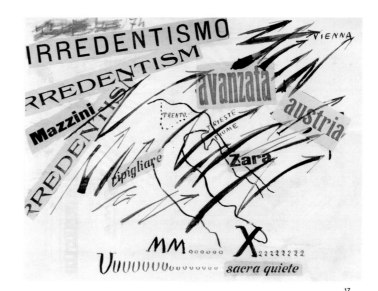

16.

<u>"Futurismo" Exhibition</u>
1912, Berlin, Galerie Der Sturm,
showing a crowd in front of a Boccioni painting

17. FILIPPO TOMMASO MARINETTI

<u>Irredentism, Liberated Words</u>
1914, ink, pastel and collage on paper,
21.8 x 27.8 cm
Private collection

17

society. They rejected the Futurists' glorification of mechanical motion as sentimental romanticism.

The Russian art scene around 1900 stood in a brisk exchange with Western Europe. Shortly after the emergence of Futurism in 1909, its agenda had already become known in Moscow and St. Petersburg, and by the time Marinetti visited the country in 1914, Michail Larionov and Natalia Gontcharova had already founded Rayonism. The two artists viewed their visual language, in which light-charged sheaves of rays seemed to dematerialize objects, as a synthesis of Cubism, Futurism and Orphism. Real life, in their utopian vision, should take its cues from the laws of painting — a demand entirely contrary to the Futurists' dogma of progress, whose point of departure was precisely the existing technological world. Kasimir Malevich, too, before founding Suprematism, went through an orientation phase he called Cubo-Futurism. Around 1911–13 Malevich began dissecting rural scenes into dynamically rhythmic segments, or — à la Cubism — into sharp-edged facets. Malevich analyzed the world of objects with the ultimate aim of developing an entirely non-objective, elementary painting. The final Futurist exhibition organized in Russia, shown in 1915 under the title "0–10" in St. Petersburg, included Malevich's renowned *Black Square on a White Ground*, 1914–15.

With Germany, England and Russia we have named the most important spheres of Futurist influence, to which the Central European region and Japan might be added. Around 1912 the Futurist vocabulary of form cropped up in many works of the best-known painters of the period, yet it was almost always blended with the idiom of Futurism's great rival, Cubism. The spirit of avant-garde revolution reigned everywhere. This either took the form of an aesthetic and formal renewal — that is, remained immanent to the realm of art — or turned to real life and attempted to define itself by reference to an involvement with non-artistic areas. An example of the latter approach was Dadaism and its far-ranging experiments with a plurality of existing materials. The Dadaists' public appearances seemed to transform the aggressiveness and revolutionary attitude of the Futurists, aimed at creating a mood amenable to visionary thinking, into a massive, cynical critique of society.

war, glorified violence, and the seeds of decay

The Futurist movement was marked by a close link between art and physical struggle. From the first manifesto through the nearly concurrently beginning actions to the visual works, Futurist aims and lan-

1926 — Fritz Lang directs the film "Metropolis"
1927 — Charles Lindbergh makes first solo flight across the Atlantic 1929–1933 — World economic crisis, the Great Depression

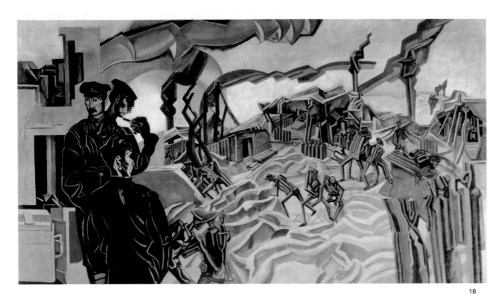

18

"Nothing being taught in schools or studios as the truth holds valid for us any longer. our hands are free and clean enough to start over from the beginning."

Boccioni, Carrà, Russolo, Balla, Severini

guage were infused with anarchy, revolutionary pathos and a glorification of violence. This belligerence went hand in hand with a patriotic attitude that was widespread at the time, a pan-Italianism that envisioned Italy at the forefront of Europe not only in the international rivalry of art isms but in every cultural and technical field as well. It was a vision that had originated in the Risorgimento, and it was only fueled by national deficits. Italy's expansionist attempts in East Africa in 1895–96 had ended in fiasco; its industrialization lagged far behind England and Germany's; and the new century saw Italy still a largely agricultural country. Although under minister president Giovanni Giolitti Italy went through a phase of political and social integration in which democratic attempts were made to resolve the conflict between a growing proletariat and established capitalist power structures, it was not until the rise of fascism that a temporary, if dictatorial, solution would be found.

This general climate was already reflected in the First Futurist Manifesto, with its notorious statement, "We shall glorify war – that sole hygiene for the world – militarism, patriotism, the destructive deeds of the anarchists, the great ideas one dies for, and a disdain of woman." This was not only a call to battle but to a war between the sexes.

Marinetti would cleave to the notion of an aesthetic war throughout his life. Walter Benjamin, in the epilogue to "The Work of Art in the Age of its Technical Reproducibility," written in 1935 and

published the following year, explicitly attacked Marinetti's stance and his inability to imagine humane uses for technological productivity. The violence underlying his attitude even infected artists' creative activity and aesthetic solutions. Under the impression of the Libya campaign of 1911, in which he took part as a war reporter, Marinetti wrote a poem, "La battaglia de Tripoli" (The Battle of Tripoli), and two years later published reflections on his experiences, "Assedio di Adrianopoli" (Siege of Adrianopolis).

By the time the First World War broke out in 1914, Marinetti had gained first-hand experience of a kind his artist colleagues lacked. Many of them, and not only Italians, went enthusiastically to war, thinking it the only way to break up the centuries of encrustation that blocked social progress. Among them was Franz Marc, who pathetically declared, "The war is being waged for purification, and the tainted blood is being shed." It was out of the same conviction that the Futurists envisioned jettisoning the moribund past and celebrating the emergence of "universal dynamism." But now they were challenged to live out the heroism they had extolled in advance of the real war. Artists had to prove themselves as soldiers and workers. The idealized imagery of battle that suffused Futurist rhetoric and art was now confronted with the brutal, day-to-day reality of a bloody war.

1930 — First issue of the journal "Cercle et Carré" appears in Paris
1930 — Futurists participate in the XVIIth Venice Biennale 1930 — André Breton publishes the "Second Manifesto of Surrealism"

18. PERCY WYNDHAM LEWIS

<u>A Battery Shelled</u>
1919, oil on canvas, 182.8 x 317.8 cm
London, Imperial War Museum

19. NATALIA GONTCHAROVA

<u>The Harvest</u>
1911, oil on canvas, 92 x 97 cm
Omsk, Museum of Fine Arts

20. KASIMIR MALEVICH

<u>The Aviator</u>
1914, oil on canvas, 125 x 65 cm
St. Petersburg, State Russian Museum

19 20

"we must invent Futurist clothing. che-e-e-erfully saucy in bright colors, dynamically simple in line, and above all short-lived, in order to encourage industrial activity and give our bodies the continual pleasure of newness."

Giacomo Balla

Even though one or the other artist abandoned the Futurist agenda before the war – Carlo Carrá officially broke with Marinetti's movement in late 1913 – the First World War evidently marked the disbanding of the original Futurist group. Its members reacted differently to the reality of war. Some sought new certainties, and followed a *"richiamo all ordine,"* the recall to order then heard all over Europe. Carrà joined Pittura metafisica, the metaphysical painting initiated by Giorgio de Chirico; Mario Sironi founded the neorealist Novecento group; Balla and Severini turned to objective painting. Umberto Boccioni began experimenting with a style oriented to that of Paul Cézanne, before a riding accident cut short his life in 1916. That same year the architect Sant'Elia fell in battle.

Futurism and fascism

After the First World War, Marinetti marshalled new forces, and his movement, politically inspired from the beginning, heightened its demand for a general revaluation of social standards. Since it consisted of a blend of radical social reform ideas and artistic visions, Futurism unavoidably became bound up with historical developments in Italy. The resulting ambivalent relationship of Futurism to fascism,

which controlled Italian politics from 1919 to 1945, has led to persistent reservations with respect to the first Italian avant-garde and to a delayed reception of the Secondo Futurismo that followed.

The year 1909 saw the publication of the "Premo manifesto politico" (First Political Manifesto). Shortly before the war, during the 1913 elections, Marinetti, Boccioni, Carrà and Russolo outlined a political agenda that included both financial protection for the proletariat and a policy of colonial expansion. In "Futurism – Basic Knowledge," written in 1920, their political aims were more clearly defined: establishment of a volunteer army, modernization of public security forces, and an Italian government led by young front-line soldiers. Yet although they increasingly clarified their political ideas, the Futurists remained more idealists than politicians, and their radical agenda had little influence on actual political developments.

Benito Mussolini, acquainted with Marinetti from 1915, nevertheless profited from the intellectual, revolutionary climate of the Futurist movement. During his rise to power, Mussolini relied on its unshakeable will to renewal, aggressive rhetoric, and the model of a tightly organized group it provided. Marinetti himself discussed this relationship in his 1924 publication "Futurismo e Fascismo" (Futurism and Fascism), emphasizing the pioneering role of his movement and its points of contact with fascism. However, as fascism

1932 — Anglo-American writer Aldous Huxley's utopian novel "Brave New World" appears

1934 — World soccer championship final in Italy (Italy – Czechoslovakia 2 : 1)

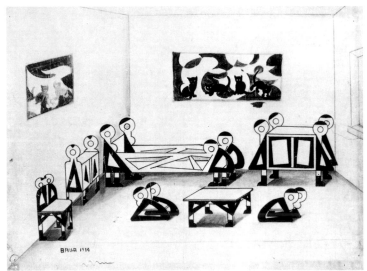

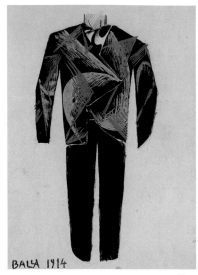

"Art must become a function of life."

Umberto Boccioni

became more firmly entrenched Mussolini increasingly distanced himself from Futurism and in fact even came to oppose it, as his power-political concessions to the conservative camp and the Catholic church made abundantly clear.

The relationship between Futurism and fascism continued to remain ambivalent. In 1929, for instance, Marinetti accepted a professorship at the newly founded Reale Accademia d'Italia, despite the fact that Futurism had always combatted schoolmasters and academics as a source of that hidebound thinking they so deplored. Artists of the second Futurist phase, such as Enrico Prampolini, Gerardo Dottori and also Mario Sironi, installed rooms in the Futurist manner at the great self-aggrandizing shows mounted by the fascist state, such as "Mostra della Rivoluzione Fascista" (Exhibition of the Fascist Revolution), held in Rome in 1932.

The cultural policy of Italian fascism differed from that of the totalitarian regimes in Germany and Russia, where modern art was mercilessly attacked and forcibly suppressed. Although Mussolini raised the canon of classical art with its Roman mythology and tendency to the monumental to the rank of official state art, modern trends were nevertheless tolerated. This could not help but lead to unresolvable contradictions. Worlds separated the fascist architect Marcello Piacentini's designs for a colossal architecture that would

last for eternity, and the Futurist architect Sant'Elia's visions of cities redesigned anew by each new generation.

A persecution of Futurism, comparable to that of Expressionism in Germany, did not come about. Yet its agenda, covering all areas of life, put it in a precarious and equivocal position with respect to politics, explaining why the Futurists oscillated between agreement, adaptation and self-determination.

Art and Life

From Secondo Futurismo to the demise of the movement, two marked developments took place. Under altered aesthetic premises, Futurism expanded in the 1920s into virtually every field of design – fashions, furnishings, cuisine, stage sets, costumes, decor, ceramics, graphic art, advertising. Art and life, *arte-vita,* began to intermerge. On the other hand, in the 1930s a number of artists took Futurist dynamism into new dimensions of time and space, with *Aeropittura,* or aero-painting.

Both tendencies were part of the so-called heroic phase of Futurism, which as a life-encompassing vision had been multi-disciplinary from the start. Back in 1910, in the "Technical Manifesto

1937 — Paris World Exposition
1939 — Hitler orders invasion of Poland, touching off World War II 1939 — Albania occupied by Italian troops

"we shall glorify war, that sole hygiene for the world!"

F. T. Marinetti

21. GIACOMO BALLA

Design for a Nursery
1914

22. GIACOMO BALLA

Futurist Men's Suit
1914

23. FORTUNATO DEPERO

Preparations for a Futurist Party
1923

23

of Futurist Painting," the authors had explicitly demanded that art play a direct role in life. Again and again Marinetti and his followers verbosely praised aeroplanes as a technological achievement and flying as an intoxicating modern experience of speed. The aeroplane appeared as a motif not only in the art of Balla, Severini and Sironi, but on an international level, as with Delaunay. Finally, both Malevich and El Lissitzky began in the late 1910s to define new, weightless models of space by means of an entirely abstract, constructivist pictorial syntax.

Between the first and second phase of Futurism, Giacomo Balla and Fortunato Depero's 1915 manifesto "La riconstruzione futurista dell'universo" (The Futurist Reconstruction of the Universe) represented both a link and a fanfare. The two authors extolled the achievements of the early years and envisioned a complete merger of Futurism with life, which would enable nothing less than a reconstruction of the universe. Again the artist appeared in the role of demiurge, but this time without his previous penchant for destructiveness. Balla and Depero's new, dynamic universe, encompassing all aspects of life, would be built in a process of playful synthesis. They went in detail into the subjects of play and playthings, and outlined training approaches that would lastingly shape children's subsequent development. Futurist toys, the manifesto declared, would further creative activity – a potential the Futurists had recognized early on, when in 1911 they invited children to submit works to their first show in Milan.

In a word, the climate in the Futurist community had changed. A synthetic, constructive approach had supplanted the analytic, destructive one of the pre-World War I phase. This change was associated with an aesthetic reorientation, in which dynamism now began to be visualized by means of what the artists termed "plastic configurations." The essential stylistic means were lucid space and elementary volumes, as well as strong, brilliant colors frequently applied in large areas. Beyond this, there were increasing experiments with non-artistic materials such as tinfoil and sheet metal, or with musical and electronic instruments.

The art produced on this basis over the following years gave the impression of plastic, convoluted narrations whose dynamism tended to be on the ponderous side. Human figures metamorphosed into mechanically constructed entities, hybrid creatures somewhere between robot and flesh-and-blood ideal, a development that had been anticipated by the humanoid fighting machine in Marinetti's novel "Mafarka-Le-Futuriste."

The same formal principles were applied to the diverse areas of life on which the artists now began to focus. Balla, who formed a new

1940 — 10 June: Italy declares war on France and England

1940 — Three Power Pact signed by Germany, Italy and Japan

1943 — 10 July: Allied troops land on Sicily

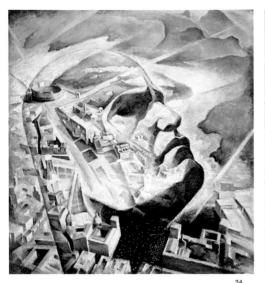

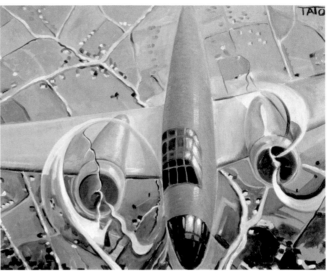

<p style="text-align:center">24</p>

<p style="text-align:right">25</p>

"we declare that the glory of the world has been enriched by a new beauty. тhe beauty of speed."

F. T. Marinetti

phalanx in Rome with Depero and Prampolini, concerned himself especially with clothing design. Balla's unusual clothes had already attracted attention back in 1912, while he was working at Haus Löwenstein in Düsseldorf. His attire ran entirely counter not only to the prevailing fashions but to the dignified look cultivated by his fellow Futurists, who always appeared in dark suits at their soirées. In 1914 Balla wrote a manifesto on "Il vestito antineutrale" (The Anti-Neutral Suit), which consisted of brightly patterned trousers and rakishly cut jacket. Even more than Futurist fashions for women, Balla's startling suit was perfectly adapted to a provocative public proclamation of the Futurist program. It was not until 1920 that Balla penned a manifesto on female fashions – a subject long relegated to the margins thanks to Marinetti's disdain of feminine sentimentality and reduction of woman to "animal values." The sole theoretical contribution to Futurism in this regard was made by a Frenchwoman, Valentine de Saint-Point, in her "Manifest della donna futurista" (Manifesto of the Futurist Woman).

The interdisciplinary approach of Secondo Futurismo became especially apparent in the *case d'arte futuriste,* or Futurist houses, which began to spread across the country like a network. The artists furnished them with handmade objects, decor, ceramics, tapestries and other things. These houses, small units for the proclamation and dissemination of Futurism, aimed at infusing society with the Futurist sense of life through exhibitions, events, publications and product sales. Yet a serial or mass production of the kind practiced in parallel at the Bauhaus was not adopted in Italy. The Futurist houses served rather to lend the performance approach typical of Futurism a new form.

One of these, Casa d'arte Bragaglia, was inaugurated by the photographer Anton Giulio Bragaglia on Via Condotti in Rome on 4 October 1918. It was followed, likewise in Rome, by Prampolini and Mario Recchi's Casa d'arte italiana and by Balla's house, which was open to the public in the afternoons. In Roverato, Fortunato Depero opened a house in 1919, in which he installed Futurist furniture and special textile tapestries. One of the few surviving examples of this intrinsically Futurist version of a *Gesamtkunstwerk,* the Casa d'arte Depero, is still open to the public today.

art with a lift: aeropittura

When Balla retired from the Futurist movement at the end of the 1920s and Depero moved to New York for a time in order to focus on his work in advertising, the face of Futurism changed once again – with the emergence of Aeropittura.

1943 — 25 July: Mussolini arrested. 3 September: Minister President Pietro Badoglio negotiates truce with Allied forces
1943 — 13 October: Italian government under Badoglio declares war on Germany

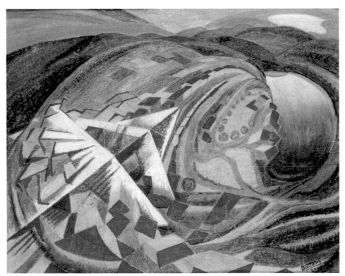

26

24. ALFREDO AMBROSI
<u>Portrait of Benito Mussolini in Front of a View of Rome</u>
1930, oil on canvas, 124 x 124 cm
Private collection

25. TATO (GUGLIELMO SANSONE)
<u>Aeroplane</u>
c. 1932, oil on canvas, no measurements given
Private collection

26. GERARDO DOTTORI
<u>At 300 Kilometres an Hour Over the City</u>
1930, mixed media on cardboard, 48 x 60 cm
Private collection

Ever since Leonardo da Vinci recorded his dreams of manned flight in construction drawings, artists through the centuries were intrigued by the experience of flying and its physical and mechanical prerequisites. The subject was a predestined one for Futurism, especially in view of the airshows which had begun at the start of the century and had made flying popular throughout Europe.

Artists like Dottori, Tato, Crali and even Prampolini, sharing Marinetti's early excitement with flight, developed an approach called Aeropittura, which was destined to be the final phase of Futurism. Once again, a cult of machinery sparked unusual perceptions, which literally gave Futurism a new lift. Previously unheard-of experiences of space and incredible flight speeds motivated an adoption of innovative points of view. One key theme was a bird's-eye view of the parabolic curve of the earth. To represent it, the artists of Aeropittura returned to formal devices from the 1920s: brilliant, but also mixed colour values and a cubistic to facetted, planar composition that infused their depictions with dynamic force. Some of these merely recorded a certain flight situation, while others completely abstracted the subject, raising it to a transcendental level in which diaphanous colour combinations evoked the airman's experience of boundless space. In view of this lyricism, Marinetti prophesied in a 1931 manifesto on Aeropittura that it would soon lead to a new "extraterrestrial spirituality" in visual art.

It was a lofty aim that Futurism was not destined to achieve. With Marinetti's death in 1944 the movement, which had already lost impetus in the wake of the First World War, virtually came to an end. The call for a "return to order" that had reverberated through Europe in the interwar period, and the neoclassicism of Pittura metafisica, had drawn off too many creative minds. In addition, the movement's ambivalent stance with respect to fascist dictatorship made it impossible for Futurism to take on a clear profile. The equation Art + Action + Life = Futurism, at the heart of the avant-garde attack mounted by a young Italian generation, no longer balanced.

1943 — Atomic bombs dropped on Hiroshima and Nagasaki

1945 — Mussolini is assassinated

The city Rises

Oil on canvas, 199.3 x 301 cm
New York, The Museum of Modern Art, Mrs. Simon Guggenheim Fund

* 1882 in Reggio di Calabria,
† 1916 near Verona

With the writer Filippo Tommaso Marinetti, Umberto Boccioni was a leading figure in the Futurist movement. The paintings and sculptures he executed from 1910–11 to 1914–15 have shaped our image of the first Italian avant-garde to this day. As a theoretician he explained his artistic approach in numerous manifestoes and in 1914 published a summing up in "Pittura scultura futuriste (Dinamismo plastico)."

The City Rises (La città che sale) is Boccioni's first Futurist work, whose symbolism and divisionistic style – characterized by the filigree network of layered colored strokes – combine all essential aspects of Futurism. The painting was preceded by a design for a triptych, *Giants and Dwarfs.* This showed, on the left field, a tree symbolizing night; in the middle, a team of horses in front of a construction site, standing for day; and on the right, a technical construction symbolizing twilight. This cycle of a day, covering the aspects of nature, labour and technology, was subsequently reduced to a considerably more cogent version.

In *The City Rises,* a big city waking in the morning in depicted. Work and traffic are getting underway, developing an intrinsic dynamism. Teams of horses, labourers, a building under construction – in the upper right corner there is an industrial area typical of the urban periphery – are caught up in swirling vortices of short brushstrokes in expressive colors, which combine into a composition of great vigour and energy. All of the details in the scene flow into one another to form a continuum in motion. Boccioni has condensed the motif into a metaphor of power in which the entry of the big city into the new industrial era is as much the subject as the early-morning street scene itself.

The horse, a work animal from the pre-industrial period, shows Boccioni's continued interest in a unification of nature and tech-nology. For him the power of the horse – often also addressed by Carlo Carrà – pointed the way to the future. This may seem to conflict with Marinetti's glorification of technical products such as cars, aeroplanes or streetcars (although their power, too, was expressed in "horsepower"). In the founding manifesto of Futurism, Marinetti described the automobile as a snorting beast and spoke of its detecting a scent and hunting down its quarry. Human beings, animals and machines were part of a symbiosis out of which ever-new metamorphoses would emerge.

In *The City Rises,* the workers contribute their physical stamina to the dynamic beginning of a new day – an echo of the socially motivated realism in Boccioni's work of 1908–09. Marinetti, in contrast, in his novel "Mafarka-Le-Futuriste," 1910, envisioned a hybrid man-machine that used its power for destructive ends only. As this implies, construction and destruction were not mutually exclusive factors in the Futurist movement.

Giants and Dwarfs, 1910

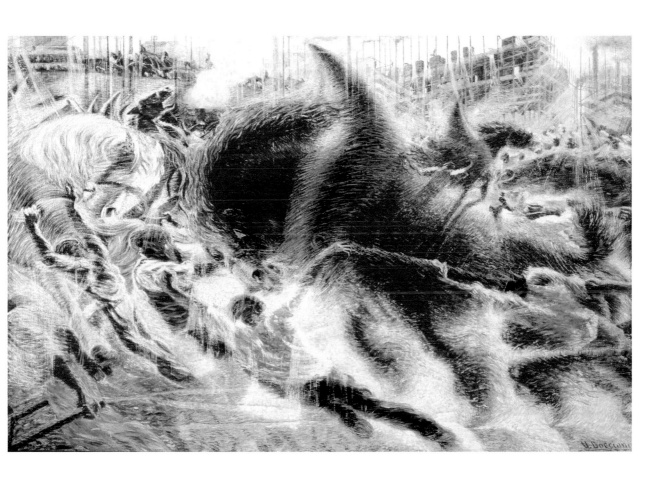

states of mind

Oil on canvas: The Farewells, 70.5 x 96 cm; Those Who Depart, 71 x 96 cm; Those Who Stay, 71 x 96 cm
New York, The Museum of Modern Art, Gift of Nelson A. Rockefeller, 1979

States of Mind (Stato d'animo) consists of three separate paintings which, each by different means, strike a common tone – a mood of solitude, lonelieness and melancholy. Seen together, they convey differently motivated and formulated states of mind associated with these feelings.

Everything begins with a train trip. *The Farewells (Gli addii)* shows a whirling current of lines in matte colors. Light grey, brown and black undulations suggest ponderous locomotives and the steam they emit while standing in the station. Pairs of embracing figures appear through the clouds of steam. *Those Who Depart (Quelli che vanno)* represents a view from a train travelling through the night. The countryside with houses and telegraph poles rushes past the window at incredible speed. This velocity is evoked by the dense web of green, blue and black strokes that suffuse the entire scene. The compartment interior and passengers' faces merge with the space outside the train to form a unity. *Those Who Stay (Quelli che restano)* shows people who have remained at the point of departure. A light green curtain of lines envelops the figures, who in turn are merely linearly evoked. Three images with three different treatments, but all conveying the same mood.

What appears to have been spontaneously painted was actually the result of precise preparatory studies. Both in these works on paper and the final paintings, line is the element that conveys the artist's message. It abstracts the motifs, and its varying course defines the emotional content of the scenes.

Boccioni often referred to the trilogy *States of Mind* to explain his theory of "pictorial states of mind." As he wrote in his 1914 book "Pittura scultura futuriste (Dinamismo plastico)," "We must consider the work of art in painting and sculpture as a construction of a new, inner reality, which, obeying a law of pictorial analogy virtually unknown to us, constructs the elements of external reality. Through this analogy – which is the essence of poetry itself – we attain to the pictorial states of mind." Boccioni speaks of "states of form" and "states of colour," and proclaims, "Every sensory emotion conforms to an analogous colour-form."

In Boccioni's art, perception, emotion and the memory of things seen and felt merged into an artistic conception of reality. In this regard, the Italian artist harked back to the Norwegian painter Edvard Munch, whose visions of solitude, melancholy and despair had already visually merged objective motifs and subjective feelings. Yet while Munch invariably addressed a personal conflict between the sexes, Boccioni aimed at conveying the loneliness and alienation that resulted from urban expansion.

Of all the Futurists, Boccioni concerned himself most intensively with the writings of the French philosopher Henri Bergson, where he in fact found his concept of *états d'âme,* or states of mind. Memory, too, played a key role in Bergson's vitalistic philosophy. Since everything in the world in caught up in a process of continual change, continual becoming – a second after seeing an object, this glimpse is already a moment in the past – the process of remembering means conserving experiences. What is conserved, in turn, can be made fruitful for the future. This is the sense in which Boccioni employed memory in the creation of his imagery.

States of Mind is one of his early major works, and it shows Boccioni already in full command of his own, individual version of the Futurist idiom.

> **"The intoxicating goal of our art is the simultaneity of states of mind in the work of art."**
>
> **Umberto Boccioni et al.**

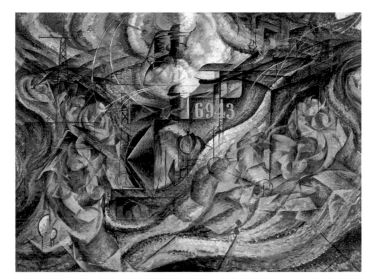

тhe street penetrates the нouse

Oil on canvas, 100 x 100.6 cm
Hanover, Sprengel Museum

The Street Penetrates the House (La strada entra nella casa) is one of the paintings which was on view in the great travelling exhibition of Futurist works. It began in February 1912 at Galerie Bernheim-Jeune in Paris and was subsequently shown in various European capitals. One station was Berlin, where Herwarth Walden, an enthusiastic novice on the international art scene, presented the second exhibition of young Italian avant-gardists Umberto Boccioni, Carlo Carrà, Luigi Russolo and Gino Severini to German audiences at his gallery, Der Sturm. The show triggered an enormous public echo, and was also a financial success. Albert Borchardt, a Berlin banker and collector, acquired a large part of the paintings, including *The Street Penetrates the House.*

With their usual verve, the Futurist painters explained their intentions by reference to visual examples in the catalogue. The superscript to Boccioni's painting, for instance, read, "The intoxicating goal of our art is the simultaneity of states of mind in the work of art. A few more examples by way of explanation. When we paint a figure on a balcony, as seen from the room, we do not restrict the scene to what one can see through the square of the window, but attempt to convey the totality of pictorial sensations triggered in the painter standing on the balcony: the bustle of the sunlit street, the double row of buildings extending right and left, balconies with flowers, etc. This means simultaneity of the surroundings, and concomitantly a displacement and disassembly of objects, a scattering and merging of separate parts, liberated from common logic and independent of one another. In order to let the viewer live in the midst of the picture, as we put it in our manifesto, the picture must be a synthesis of remembering and seeing."

There could hardly be a better description of the formal and substantial message of *The Street Penetrates the House* – various sense impressions depicted in simultaneity, combined with remembered or mentally associated experiences. The operative term here for the Futurists was simultaneity, and Boccioni was the first to put it into convincing visual practice in the present painting. A stylistic model was provided by the Eiffel Tower depictions of the French painter Robert Delaunay. Yet Boccioni had a much more comprehensive notion of reality than Delaunay, and faced the challenge of how adequately to depict it on a flat canvas. How he did so is also seen in subsequent paintings like *Simultaneous Visions* and *The Forces of a Street,* both 1911.

In *The Street Penetrates the House,* we as viewers are encouraged to watch, together with the female figure leaning over the balustrade, the unfolding spectacle in front of and around the balcony. The buildings tilt forward, are facetted like crystals; many individual elements, including the balcony scene itself, are repeated; objects interpenetrate, and a small horse, which one would think of as on the ground below, cuts across the woman's figure high above at the balustrade. The ordering effect of one-point perspective seems to have gone out of kilter. Solid bodies have lost their material properties and diffuse into the surrounding space. Everything in the picture appears to implode and stream towards the figure's head. Her mind is the focus of sense perceptions and reservoir for the multifarious impressions evoked by the scene.

The Forces of a Street, 1911

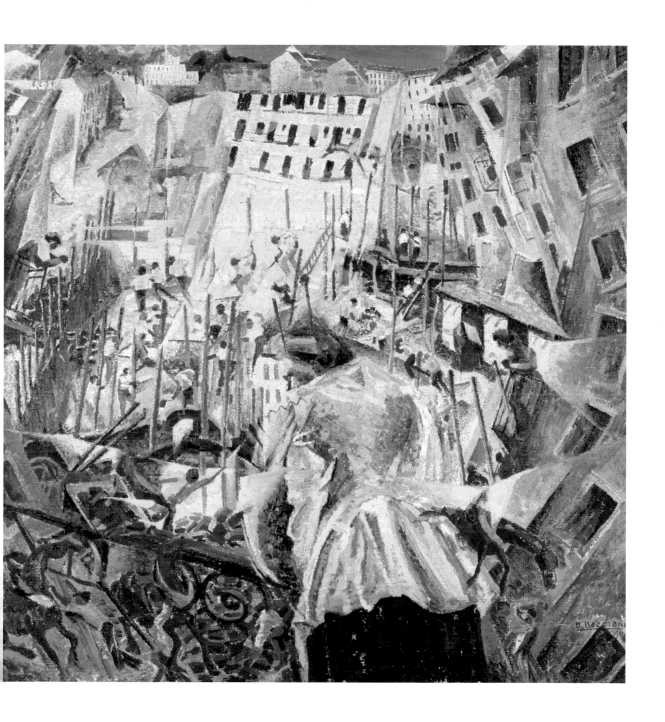

Hand in Motion

Photograph, 13 x 18 cm
Rome, Collection Antonella Vigliani Bragaglia, Centro Studi Bragaglia

* 1890 in Frosinone,
† 1960 in Rome

After the development of reproducible imagery in the nineteenth century, the equation of photography with art became a bone of contention among visual artists, art theoreticians and photographers. The new medium in fact initially emulated painting and vice versa, many artists employing photos as memory aids or sources of inspiration. Around 1900, however, photographers began to strive for artistic autonomy in their medium. Futurism, with its aesthetic of universal dynamism, provided a fruitful point of departure in achieving results that were independent of traditional art.

Although the photographic medium was controversial in the core Futurist group in Milan – Umberto Boccioni rejected it as unartistic, while Filippo Tommaso Marinetti supported experiments with the camera – the two brothers and amateur photographers Anton Giulio and Arturo Bragaglia developed "photodynamism" in spring 1911. Familiar with Futurist theory and manifestoes, and probably inspired by Boccioni's lecture of 29 May at the Circolo Artistico Internazionale in Rome, in which the visual arts pioneer spoke about his dynamic painting, the Bragaglias produced their first photodynamic pictures in mid-1911.

Their point of departure was the inadvertant gestures people often make. In *Hand in Motion (Mano in moto),* Anton Giulio Bragaglia concentrated on one of the most agile parts of the body, the hand. Several lamps were used to flood the motif with bright light, isolating the course of the gesture in the darkened room. By means of a long exposure time, the hand's motion was captured in the photo as a blurred trace of light.

The motion photography done by this method diametrically differed from the motion analyses undertaken in "chronophotographs" by the Frenchman Etienne-Jules Marey at the end of the nineteenth century, as well as from the photographs of Jacques Henri Lartigue, who,

around 1910, froze movements in imagery in which the force of gravity seemed suspended. In Bragaglia's *Hand in Motion,* in contrast, the figure in action seems almost completely to dissolve, and the blurred movement suggests the energy released in the gesture. The Bragaglia brothers viewed this effect as corresponding to the *élan vital,* that life force which was the essence of the Futurist conception of reality. In their own way, they overcame mere imitation of reality and brought photography into the realm of art as an independent and productive medium.

Anton Giulio Bragaglia explained his theory of photodynamism in an essay, "La fotodinamica," in 1910. The following year he expanded his considerations in a volume of essays, "Fotodinamismo." A comprehensive exhibition of Bragaglia's works in this direction was held in Rome in 1912. Although the brothers' photography had yet officially to be accepted as art by the Futurists, they continued their experiments in the field of photodynamism. Prepared for by a self-portrait like *Person on a Staircase,* a whole series of "polyphysiognomic," or multifaced, portraits emerged in 1912–13. In the latter year the brothers began to predetermine the course of gestural movements and exert control over what had previously been spontaneous. Beyond this, they developed a "sandwich technique," in which several negatives were superimposed over one another.

Person on a Staircase, 1911

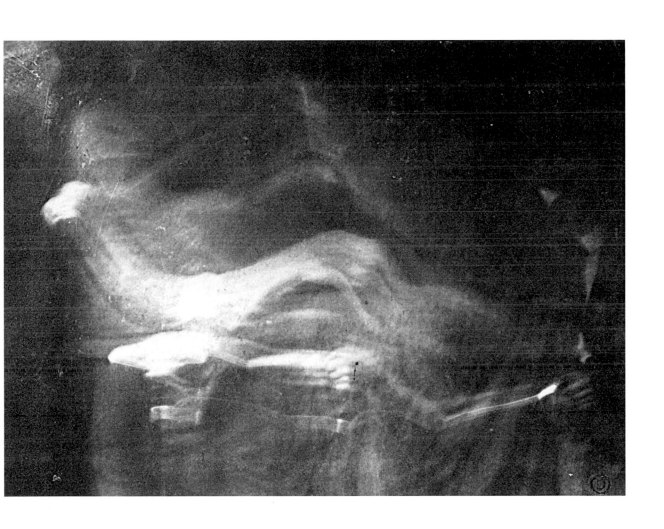

Rhythms of objects

Oil on canvas, 53 x 67 cm
Milan, Pinacoteca di Brera

* 1881 in Quargnento,
† 1966 in Milan

Carlo Carrà signed the "First Manifesto of Futurist Painting" in 1910. This brought him into the nucleus of the Milan group around Marinetti, and like his colleagues, Carrà was animated by a belief in a universal model of a world impelled by motion. For him, too, reality consisted of dynamism, disassembly, interpenetration and simultaneity – the parameters of Futurism. Beyond this, his oeuvre was characterized by a special feature not found to a comparable extent in the work of other Futurist painters: the phenomenon of three-dimensionality depicted on a flat plane, to which Carrà intensively devoted himself. An interpenetration of plastic elements with the surrounding space concerned him much more than, for instance, the rendering of figures or objects, such as automobiles, in motion.

Rhythms of Objects (Ritmi di oggetti) belonged to the early Futurist phase and was one of a series of paintings in which Carrà clearly oriented himself to French Cubism, for he did not share Boccioni's radical rejection of Cubism as a style that traditionally cleaved to the object. In 1899–1900, on the occasion of the World Exposition, the young artist had spent his first protracted period in Paris. In autumn 1911 he made his second trip there, and met Picasso, Braque, Gleizes, Léger and many other artists of the young French avant-garde. Like the Cubists, Carrà involved himself with the approach of the old master of modernism, Paul Cézanne (1839–1906). Cézanne once demonstrated the way his pictorial structure worked by interlocking his fingers. Carrà, too, took this interlocking of forms as his model.

This is clearly shown by the visual syntax of *Rhythms of Objects* and its veritably architectural structure. In the Cubist manner, Carrà has reduced his palette to a few subdued values, accented only by an occasional red-blue contrast. Passages of colour create transitions between the separate forms, which in turn are partially contoured by black lines. A still life provided the point of departure for the composition. Although rudiments of certain objects can be identified, the overall motif is difficult to reconstruct. With the abrupt appearance of a red number 2 at the left edge, a formal trick of the collage technique finds entry into Carrà's painting.

Yet despite formal borrowings from Cubism, Carrà shows himself to be a dyed-in-the-wool Futurist. In contrast to the usually centered Cubist compositions, here the elements flow in a kind of all-over to the picture edges and beyond. The pictorial framework, in Picasso and Braque paintings generally built solely of horizontals, verticals and diagonals, is enriched by arc segments running in various directions. It is above all these curves, whirls, cylinders and cones that put Carrà's objects in a state of rhythmic and dynamic dissolution. If the Cubists set out to combine different points of view of static objects, Carrà and his Futurist confreres attempted to visualize their relative and potential intrinsic motion. In Futurism, space ceased to exist, leaving only a series of mutually interpenetrating masses.

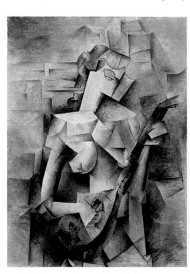

Pablo Picasso, Young Girl with Mandoline (Fanny Tellier), 1910

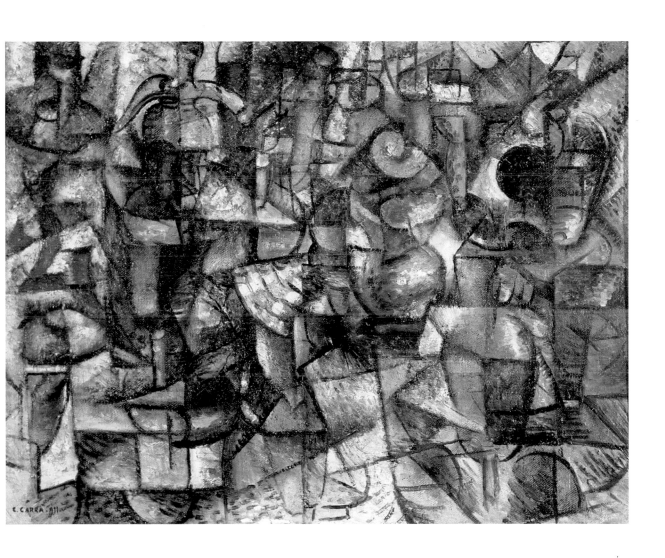

Funeral of the Anarchist Galli

Oil on canvas, 198.7 x 259.1 cm
New York, The Museum of Modern Art

In the course of the tumult during a general strike, the anarchist Angelo Galli was shot dead in Milan in 1904. Carrà described the context in which his painting emerged in his autobiography: "In front of me I saw the coffin, covered over and over with red carnations, which rocked threateningly back and forth on the shoulders of the bearers; I saw how the horses began to shy, how sticks and lances clashed, such that it seemed to me that sooner or later the coffin would fall to the ground and be trampled on by the horses. Hardly had I arrived back home when this drawing emerged under the strong impression of this incident. This and other, subsequent drawings later formed the point of departure for the painting *Funeral of the Anarchist Galli*. And it was the memory of this dramatic scene that suggested to me the following sentence for the 'Technical Manifesto of Futurist Painting': "We put the viewer in the midst of the picture."

Around 1900 Italy found itself in a difficult position due to the effects of industrialization. The aristocracy as much as the upper bourgeoisie cleaved to traditional power structures, while the growing proletariat developed a popular movement that fought for social justice. In this political situation, repeated and often bloody conflicts took place, especially in Milan, where the workers were well organized. The crisis reached its first culmination in 1898.

Carrà had moved at the age of fourteen to Milan, where he initially worked as a decorator. He lived in very humble circumstances. In Milan Carrà encountered the potential for violence of the workers' revolt, and when in London in 1900 he met the circle of Italian anarchists who had fled to Great Britain after the great 1898 riots. He immersed himself in the writings of Karl Marx. Long periods of Carrà's life would be shaped by a combination of political awareness and artistic activity. This is why social factors played a greater role in his visual conceptions than in those of most of his Futurist confreres.

Funeral of the Anarchist Galli (Funerali dell'anarchico Galli) shows a visual idiom typical of Futurism: countless figures dynamically interlocked in forceful, unified action. Only here and there do separate figures or details of the cityscape, such as the scaffolding at the upper left edge, emerge from the network of lines, strokes and forms imbued with motion. An arc of brown, red and yellow tones and a contrasting blue heighten the compositional tension. Sunrays in the sky elicit further effective light-dark contrasts.

Aside from the enormous potential of force and violence suffusing the scene, the aspect of memory is of crucial meaning here: the painting was done a full seven years after the event. As this implies, it was composed both out of remembered visual impressions and emotional reactions. In Futurist art theory, the technique of working with memories, connotations and associations was subsumed under the concept of simultaneity. In this sense, Carrà created a modern history painting which required no literary reference or historical exactitude to unfold its compelling effect.

> **"The art of the past is great nonsense, based on moral, religious and political principles. Only with Futurist art does true art emerge."**
>
> **Carlo Carrà**

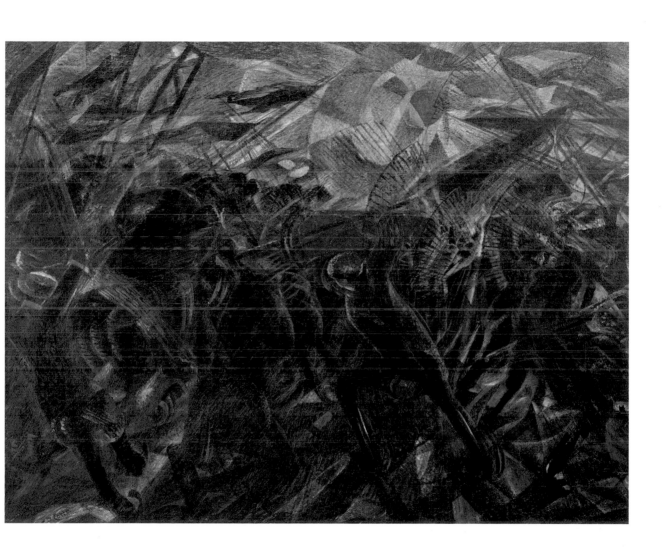

The Revolt

Oil on canvas, 150 x 230 cm
The Hague, Gemeentemuseum

* 1885 in Portogruaro,
† 1947 in Cerro near Laveno

Luigi Russolo was a member of the Futurist group in Milan. One of the signers of the "Manifesto of Futurist Painting," by 1913 he had completed numerous compositions that reflected the cult of machinery and doctrine of Futurist aesthetics. Yet that same year his interest in music prompted him to change fields and begin experimenting with sounds and noises. The artist's love of music was already reflected in his Futurist paintings. More than his other Italian colleagues, Russolo concentrated on mighty, orchestral chords produced by a few strong colors. These compositions are shot through by synaesthetic stimuli that convey both visual and acoustic experiences.

The Revolt (La rivolta) is one of the early Futurist works to address the current political situation in Italy. Russolo had been living since 1901 in the prospering big city of Milan. Like Umberto Boccioni and Carlo Carrà, he had first-hand experiences of the labour uprisings, unrest and social injustices that grew out of the conflict between rapid industrialization and an outmoded social structure.

In a painting like *The Revolt,* the Futurist attempted to bridge the gap between utopia and reality. Russolo distilled that aspect from the phenomenon of revolt which could be made fruitful for the Futurist aesthetic. Not social injustices or the workers' plight were his theme, but the violence that potentially could be unleashed by the proletariat. Bright, even blatant colors produce a sense of aggression. The strongest colour contrast is formed by red and blue, augmented by a garish yellow. This powerful triad is only slightly mitigated by the interwoven green. The crowd in revolt is depicted in the form of a wedge advancing precipitously from the right into the blocks of buildings, which seem to retreat from the advancing masses. Human beings are depicted not as individuals but as stylized prototypes reproduced many times over. Together they develop a power that presses forward in the shape of acute red angles repeated at intervals. These "dynamic lines of force," Boccioni's term for vectors moving in a certain direction, seem to embody the belligerent pulse-beat of the crowd, which suffuses the entire urban scene.

This formal abbreviation, manifested especially in the angles like arrow points, clearly distinguishes Russolo's treatment of the subject of revolt from comparable depictions by his Italian colleagues. Carrà's *Funeral of the Anarchist Galli* and Boccioni's studies for a *Brawl,* both also done in 1911, likewise translate the energy of an agitated crowd into a metaphor for power. Yet these compositions employ the Futurist device of interpenetration. Rather than establishing a certain dominant direction, they merge all the separate elements of a scene into one another. The result is an inextricable interweave of line and form that, beyond a sense of dynamism, conveys the impression of a chaotic, anarchic situation. Russolo has done without this aspect of revolt. His visual syntax has a lucid, ordered appearance. Over the din of battle one can almost hear a pleasing musical harmony in the air.

"If our art is Futurist, this is because it is the result of ethical, aesthetic, political and social ideas which are entirely futuristic."

The Futurists

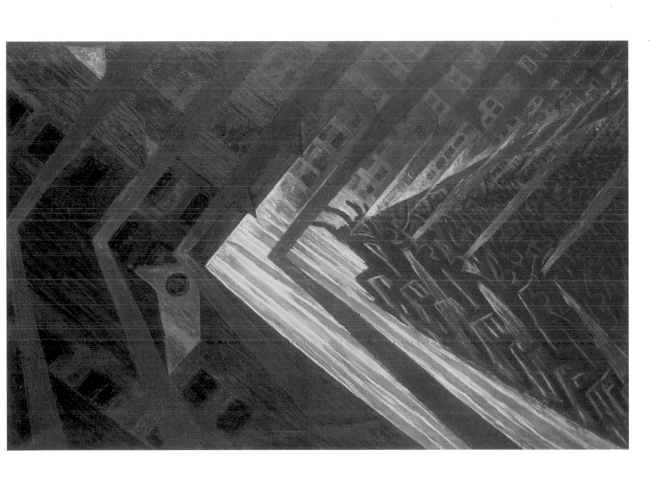

music

Oil on canvas, 220 x 180 cm
Private collection

Music and art are two fields of sensory experience that have frequently been treated as a unity by visual artists, especially in the first two decades of the twentieth century. At that time, pictures were often described in musical terms, such as the "sound" of colours, colour chords, composition, dissonances and harmonies. Scientific insights led many artists to note the relationship between the light waves emitted by colours and the waves by which sound travels through the air. The path to abstraction in art opened a wide field which encouraged a visualization of synaesthetic impressions without reference to actual objects.

Like Carlo Carrà, Luigi Russolo was a Futurist who devoted himself equally to painting and music. Carrà wrote a manifesto in 1913 entitled "La pittura dei suoni, rumori, odori" (The Painting of Sounds, Noises, Odours), in which he applied the Futurist principle of the simultaneity of diverse impressions to the senses of sight, hearing and smell. That same year, Russolo entirely ceased painting (and would not resume until the late 1920s). He now began to concentrate on the realm of sound, and with his *intonarumori,* or noise instruments, he invented the field of noise music, the outstanding contribution of Futurism to the development of music in the twentieth century. At the end of the 1940s, representatives of *Musique concrète* would follow the Futurists' lead and employ noises and sounds that originated in the everyday environment.

By the time he painted *Music (La musica)* in 1911, Russolo had immersed himself in a realm in which colours and musical notes entered a symbiotic union. Writing in the journal "Poesia" in 1920, the artist explained his painting in retrospect: "With this picture the painter attempted to translate into painting the melodic, rhythmical, harmonic, polyphonic and chromatic impressions which make up the whole of a musical sensation." The dark, undulating band, he said, traced the course of a melodic line, and the masks with their vivid expressions represented harmonic or complementary chords.

Russolo approached music by means of a symbolic visualization of the experience of a colour chord and a personification of musical sounds. With the depiction of a piano extending across the lower part of the composition, he integrated a mechanical, technical element in his evocation of the music of colour. Instrument, colours and sounds form a causal unity.

In fact, ever since the eighteenth century many attempts had been made to directly link piano playing with the effects of coloured light. The Russian composer Alexander Scriabin planned to include just such a colour piano in his "Prometheus – A Poem of Fire," performed in Moscow in 1911, although it was not until the 1915 New York performance that the piece was accompanied by a light-keyboard. Scriabin's composition was mentioned in the almanach of Der Blaue Reiter, published by the eponymous group of German Expressionists in 1912. Wassily Kandinsky was inspired by the Prometheus theme to his stage project "Der Gelbe Klang" (The Yellow Sound). The Scriabin performance touched off a whole series of inventions. The Russian painter Vladimir Baranoff-Rossiné presented what he termed an Optophonic Piano in Moscow in 1923, and in Germany, the Hungarian Alexander László demonstrated his Sonochromatoscope. Russolo's painting *Music* inadvertently brings such light-and-sound instruments to mind.

"The painting of tones, noises and odours strives for… the arabesque as the sole reality created by the artist in the depths of his sensibility…"

Carlo Carrà

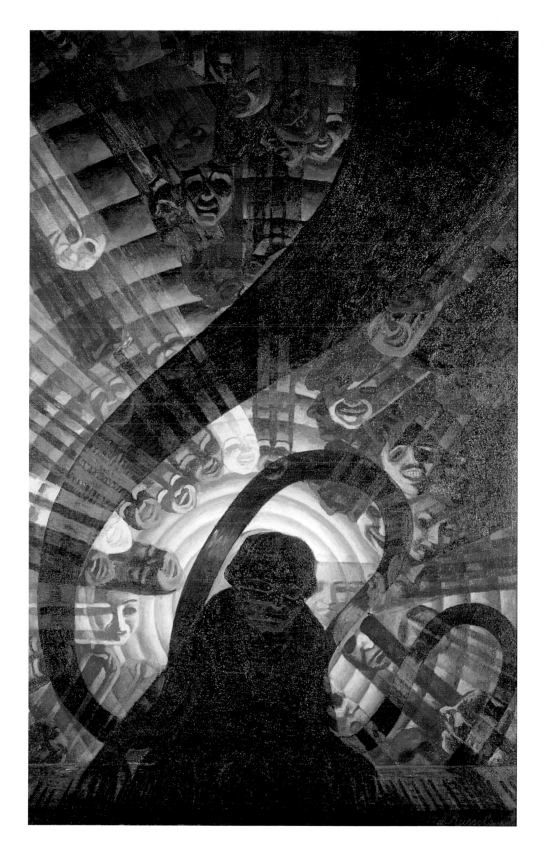

Dynamism of a Dog on a Leash

Oil on canvas, 89.85 x 109.85 cm

Buffalo, Albright-Knox Art Gallery, Bequest of A. Conger Goodyear and Gift of George F. Goodyear, 1964

* 1871 in Turin,
† 1958 in Rome

Giacomo Balla's oeuvre was characterized by continual development. In the first phase of Futurism, Balla defined a type of dynamism that captured physical motion in the painted image. In parallel he developed colour-light schemes and varied them in a range of patterns. After 1915 Balla explored the potentials of expansive plastic forms that reflected a universal Futurist theory of energy. In addition, he translated his pictorial approaches into craft applications.

Dynamism of a Dog on a Leash (Dinamismo di un cane al guinzaglio) is the first Futurist painting in which Balla defined his position as if in a visual manifesto. He has divided the movements of a woman walking her dog into multiple separate motion sequences. A horse did not have four but twenty legs, maintained the "Technical Manifesto of Futurist Painting," which Balla among others signed in 1910. The device of multiplying limbs was developed by reference to the chronophotographs of Etienne-Jules Marey, who back in 1882 sequentially reproduced the gait and flight of human beings, animals and birds using a special construction known as a photographic gun. Marey's analysis resulted in a graphic sequence of motions, which Balla copied almost exactly in studies made in 1912.

In the present painting, however, he has condensed these phases of movement to produce an effect of blurring, which recalls the motion photographs made at the same period by the Futurist photographers Anton Giulio and Arturo Bragaglia. Photography and film – Balla was co-author of the film "Vita futurista," made by Arnaldo Ginna in 1916 – formed important points of reference for painters in this phase. Such influences are seen in *Dynamism of a Dog on a Leash* in the unusual excerpt of the street scene. We look down at a stretch of sidewalk, seeing only the feet of the woman passing by, whose dog occupies the center of interest.

Balla modified two phenomena familiar from the history of art. House pets and the *flâneur,* the idle stroller along the Paris boulevards, had been discovered as motifs by the Impressionists and Post-Impressionists in the latter half of the nineteenth century. In George Seurat's (1859–1891) famous Pointillist painting *Sunday Afternoon on the Ile de la Grande Jatte,* 1884–86, a monkey and a dog added an iconographical element to a composition based on the laws of optics. Balla, in his depiction of a pet in the big city, produced a strange mixture of the dandified aloofness of the flâneur and a view focussed on a detail of the street. The picture, perhaps inadvertently, reflected a changing social structure. Pets – usually dogs or cats – had for centuries been the prerogative of the aristocracy, but now, at the start of the twentieth century, the upper-middle class began to keep pets as a sign of their new prosperity. Employees who worked in the growing industrial sector or in offices on the urban periphery demonstrated their new social status by walking their four-footed friends through town.

This conspicuous public display clashed with the dynamism of Futurism, and Balla commented accordingly. By centering the dog and radically cutting off the woman's figure, he parodied not only the relationship between human being and animal but the ossified Italian social system as a whole.

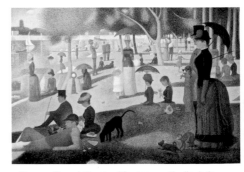

Georges Seurat, Sunday Afternoon on the Ile de la Grande Jatte, 1884–86

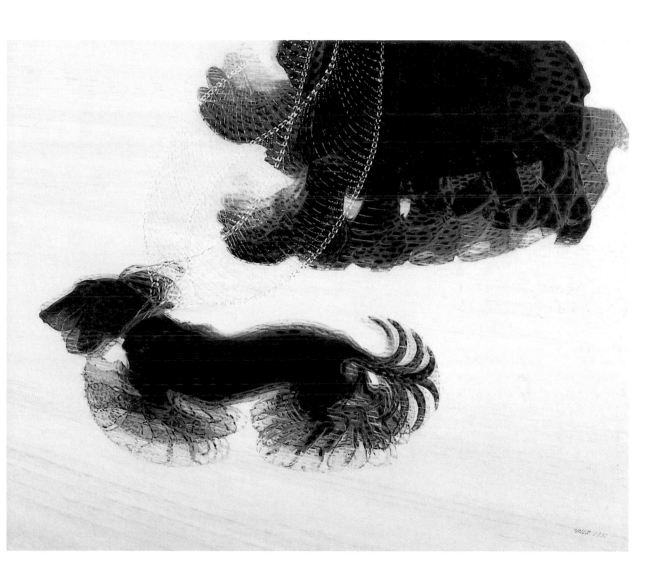

Girl crossing a Balcony

Oil on canvas, 125 x 125 cm
Milan, Galleria d'Arte Moderna

In *Girl Crossing a Balcony (Bambina che corre sul balcone)*, Balla applied his scientific interest in analyses of motion and light to a painting. The chronophotographs of Etienne-Jules Marey and the "photodynamism" of the Bragaglia brothers, his Futurist confreres, inspired Balla to multiply forms as a way of conveying an impression of movement. Balla's experiments with colour and light, on the other hand, went back to French Post-Impressionism. His first relatively long stay in Paris in 1900, on the occasion of the World Exposition, already brought an involvement with the Divisionism of George Seurat and Paul Signac (1863–1935).

Seurat modified the Impressionist practice of composing an image of short curving strokes or "commas" of paint. He built up his motifs of uniform, small dots in relatively pure colour values, which optically blend and congeal into an image in the viewer's eye. Among Seurat's sources was the colour theory of the chemist Michel-Eugène Chevreul, whose essay on simultaneous colour contrasts, "De la loi du contraste simultane des couleur et de l'assortiment des objects col-oriés," 1839, had already inspired artists like Eugène Delacroix (1798–1863) to experiment with colour on a scientific basis. Simul-taneous contrast refers to the supplementary colour which the eye automatically seeks when viewing a certain other colour. For example, yellow induces a reddish blue, blue a reddish yellow, and purple a green, and the interplay of these colour pairs engenders a harmonious overall image. Before Balla made use of this effect in *Girl Crossing a Balcony,* however, he investigated the behaviour and effects of colour and light on a completely non-objective level.

In 1912 he painted a series of *Compenetrazioni iridescenti (Iridescent Interpenetrations)*, analyses of colour based on kaleido-scope-like diagrams. Balla first began developing these during a stay in Düsseldorf, where the Löwenstein family commissioned him to adorn their home with paintings and decorations. There the artist like-ly discovered the colour pyramids of Johann Heinrich Lambert, an eighteenth-century physicist and philosopher who devoted himself to the measurement of light intensity and the laws of light absorption. Balla now commenced to divide the colour spectrum into triangles of equal size, fill them with colours of different intensity – adding white to lighten a colour – and combine them into systems. These optical

rhythms, by the way, emerged in parallel with Robert Delaunay's disc paintings *(Disques simultanés),* in which the French artist attempted a "rotating" colour analysis based on Chevreul's colour wheel.

Balla made use of the insights he had gained in *Girl Crossing a Balcony.* Bright light dissolves the balcony scene into countless units of colour. Augmented by a multiplication of forms, the subject diffuses into a pattern of pure colour. The separate elements – girl, balustrade, door frame – melt into a vibrating coloured plane in which spatial perspective is entirely negated. With his knowledge of colour relationships and their effects, Balla translated the objective motif into a conceptual system and, by so doing, inquired into the laws under-lying real appearances.

"we Futurists have discovered form in movement and the form of movement."

Umberto Boccioni

Dynamism of a soccer player

Oil on canvas, 193.2 x 201 cm
New York, The Museum of Modern Art, The Sidney and Harriet Janis Collection

In *Dynamism of a Soccer Player (Dinamismo di un foot-baller)*, Boccioni achieved the highest level of abstraction. We can only speculate as to what elements in this complex of forces possess objective or figurative references. The painterly means of colour and form have been liberated and given unrestricted autonomy. Centrifugal and centripetal forces are played off against each other at the centre of the nearly square composition, where a heavy, tightly interlocked configuration borders on a lighter, expansive surrounding field. In detail as in the overall composition, Boccioni has exploited the relationships of tension that result from colour contrasts such as red versus blue, or from formal contrasts such as plane versus volume, to evoke a pure, dynamic state. In *Dynamism of a Soccer Player* he created a visual cipher for that universal model of motion he repeatedly advanced in theory.

To Boccioni such a cipher represented the "primordial form" he sought, the "unique form which represents continuity in space." In his most comprehensive theoretical work, "Pittura scultura futuriste (Dinamismo plastico)" (Futurist Painting and Sculpture [Pictorial Dynamism]), 1914, Boccioni discussed this concept of primordial form and explained his procedure: "Dynamism is the lyrical approach to forms, which are interpreted in the endless phenomenon of the relativity of absolute and relative motion of surroundings and object, down to the formation of an overall phenomenon: surroundings + object. It is the creation of a new form, intended to represent the relativity of mass and extension. Between rotating and circling motion, in other words, life itself is captured in the form which life engenders in its endless succession."

Boccioni has defined such a primordial form in the present painting. Yet it still refers – if in the title only – to an actual motif, a soccer player. Robert Delaunay, Boccioni's great rival in the field of simultaneity, showed a picture of a soccer team, *The Cardiff Team,* in 1913 at Der Sturm gallery in Berlin, where the Futurists also exhibited. Such sport motifs were not widespread among the Italians, despite their country's long tradition of ballgames. *Calcio,* an early form of soccer, was already mentioned in an anonymous poem of 1460. A historical festival, the "Calcio Fiorentino," is still held every year on Piazza di Santa Croce in Florence. It commemorates an event of 1530, when young Florentines continued their soccer game despite the siege of the city by Charles V's troops. This not only demonstrated their indomitable will but made light of an overwhelming adversary.

This provocation seems to echo in the challenging maxims and presumptuous self-stylization with which the Italian Futurists launched their movement at the start of the twentieth century, and which remained an integral part of their agenda.

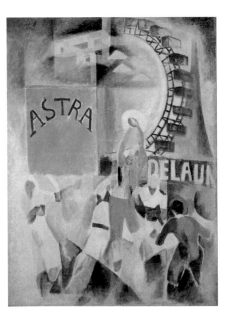

Robert Delaunay, The Cardiff Team,
1912–13

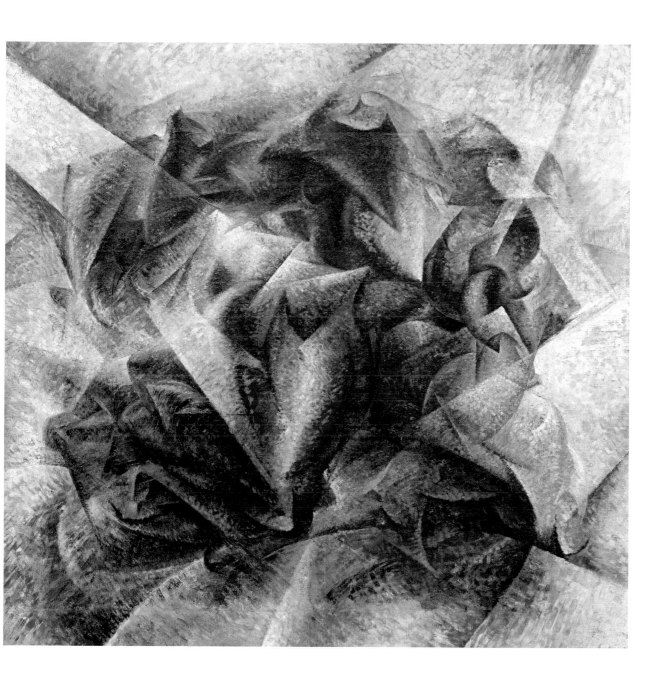

unique Forms of continuity in space

Bronze, 115 x 90 x 40
London, Tate Modern

For two years, from the middle of 1912 to early 1914, Boccioni explored the potentials of sculpture. After the opening of the first Futurist exhibition in 1912 he stayed on in Paris for a time, visited Medardo Rosso, an impressionist sculptor much admired by the Futurists, and in his studio saw works by Alexander Archipenko, who was just beginning to experiment with concave forms and polychromy.

Boccioni set out to translate the basic principles of Futurism, universal dynamism and the idea of simultaneity, into three dimensions. In the "Technical Manifesto of Futurist Sculpture" (dated 11 April 1912, but probably not written until later), the artist followed the usual Futurist practice by summing up his theoretical insights into the field of sculpture. The traditional values represented by bronze monuments and sculptures of nudes were radically rejected, and the demand raised that sculpture and space be integrated on the basis of motion. "It goes without saying," declared Boccioni, "that we shall create a sculpture of the surroundings."

Subsequently fourteen sculptures emerged. Their exact chronology is still unclear, since most of them have not survived and are known only from photographs. Boccioni rejected the method of bronze casting, working instead mostly in plaster of Paris – a material that is extremely prone to damage. One such plaster sculpture was a massive half-figure of a woman for *Head + House + Light*. Boccioni applied paint to these pieces and also integrated fragments of real things, in this case a section of a balcony railing. This sculpture was a three-dimensional counterpart to the painting *Matter,* 1912, in which the artist explored the aspect of simultaneity foremost.

In *Unique Forms of Continuity in Space (Forme uniche della continuità nello spazio),* in contrast, the full-length figure striding energetically forward shifts the accent to the aspects of motion and vitality. Boccioni has set the figure in an active advancing movement that appears to take possession of the space. The contours of the figure, whose limbs are difficult to make out, are repeatedly interrupted. Its solidity and coherence appear to explode and open out into the surrounding space. In a dynamic interchange, sculptural elements penetrate into space and the space penetrates into the figure. With this modelling of the atmosphere, as Boccioni termed it, he succeeded in evoking the factor of dynamic interpenetration in the field of sculpture as well.

Unique Forms of Continuity in Space was part of a series of four sculptures on which Boccioni worked from the end of 1912. These represented four different potential states of a penetration of a striding figure into its surroundings. In *Synthesis of Human Dynamism,* likely the first work in the series, the figure still appeared comparatively naturalistic despite its fraying contours. In the following pieces Boccioni increasingly abstracted the figure until it bore no more than vestiges of a human appearance, as seen in *Unique Forms of Continuity in Space.* By this point the human being had become entirely faceless, passed through a metamorphosis at whose end stood the humanoid fighting machine, the cyborg of Futurism.

Synthesis of Human Dynamism,
1913

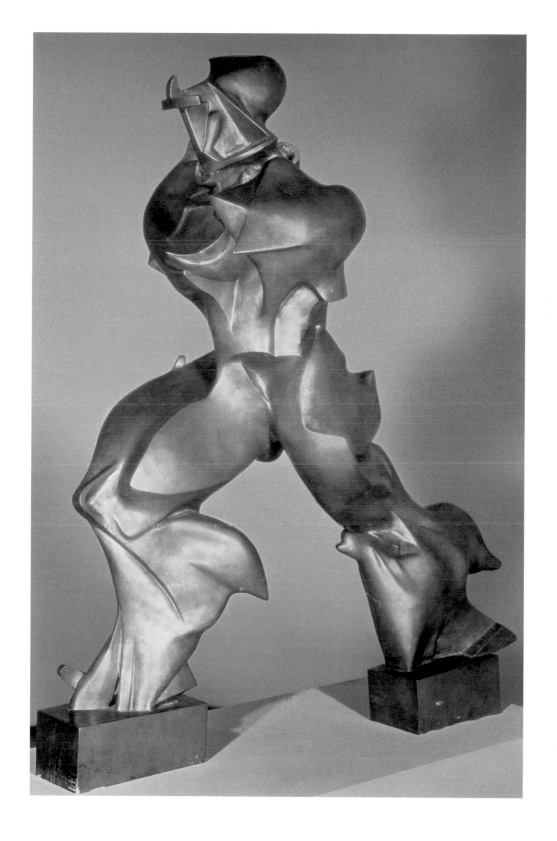

Expansion of the Lyrical

Oil on canvas, 129.5 x 129.5 cm
Private collection

* 1885 in Venice,
† 1975 on Lago Maggiore

Leonardo Dudreville belonged to the Futurist movement from the start, although he was not a signer of the "Manifesto dei pittori futuristi" of February 1910. As early as 1912 he founded the group Nuove Tendenze – generally consi-dered a more moderate Futurist faction – with the result that his name tends to crop up in the reception of Futurism only secondarily.

In 1906–07, on a trip to Paris, Dudreville became acquainted with Gino Severini. Severini's approach, an interplay of colour theory, symphonic and dynamic aspects, directly influenced Dudreville's painting. Around 1913, when *Expansion of the Lyrical (Espansione della poesia)* emerged, both artists were searching for an abstract visual language based on Futurist parameters. Severini advanced to his *Expansions sphériques,* in which colour and light expanded wave-like into a universal space. He described his notion of an ideal abstract composition in the manifesto "Analogie plastiche del dinamis-mo," 1913. Speaking of form, Severini described an "arabesque, rhythmical construction, purposely ordered with regard to a new, qualitative architecture," and then went on, "suppression of the straight line, which is static and amorphous as a colour without nuances, and of parallel lines." Severini translated such demands into a coloured visual architecture consisting of multifarious tightly interwoven geometric shapes.

In *Expansion of the Lyrical,* Dudreville modified the phenomenon of spherical expansion in an original way. He limited himself to the arc shape as the sole constructive element. Numerous arcs of different colours are disposed over and behind one another. Transparent paint layers, intense colour contrasts, and the different dimensions of the individual segments lead to an interpenetration of the abstract elements which creates an impression of depth. The inadvertant association with a rainbow, the quintessential phenomenon of a colour spectrum appearing in the sky, underscores the sense of an immaterial, spatial expansion.

Yet unlike Severini's regimented demands on painting, Dudreville's colour combinations reveal no theoretical superstructure. Blue and red occasionally form a strong contrast, and a dark blue-vio-let following a light yellow produces a contrast of intensity, yet, thanks especially to the sequences of green, yellow and orange, the overall composition is characterized by a quite harmonious colour structure.

Robert Delaunay in France was concurrently developing his disc paintings *(Disques simultanés),* whose colour combinations and arc segments are definitely comparable in general effect to Dudreville's. "There began," Delaunay once explained, "the period of the 'disques simultanés,' circular forms where colour is used in its rotating essence and the form develops out of the circular, dynamic rhythm of colour… But which colours? Red and blue, juxtaposed at the centre, produce ultra-rapid vibrations, visible to the naked eye, physically – an experience I once compared to the blow of a fist. Around this centre, always in circular forms, I disposed other contrasts, all opposed to each other and at the same time to the whole of the painting, the totality of the colours, some in complementary, others in non-complementary tensions."

Although Delaunay, like Severini, subjected his circular colour compositions to certain rules, he retained great freedoms due to the many possibilities of combination his palette presented. The selection of colours in *Expansion of the Lyrical* reflects a similar conception. In the face of widespread Futurist doctrines, Dudreville made an approach to painting based on intuition fruitful for Futurism.

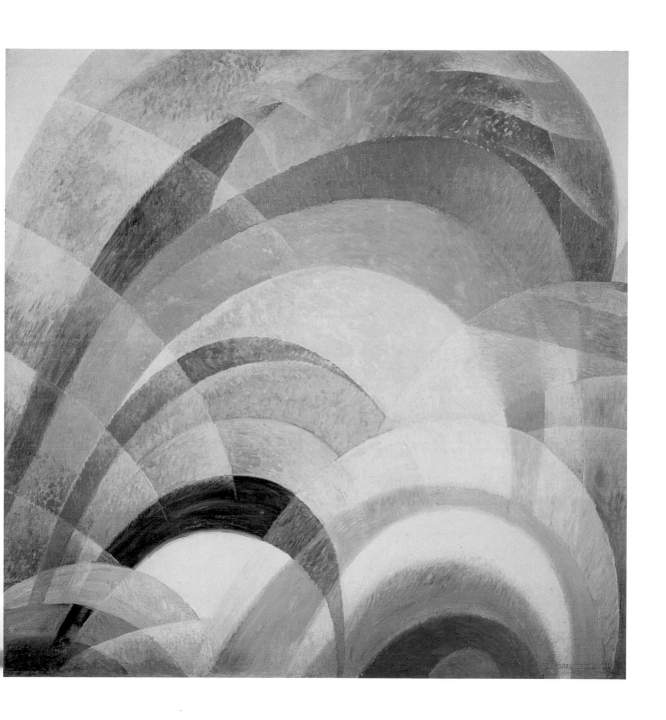

Dynamism of an Automobile

Oil on canvas, 106 x 140 cm
Paris, Musée national d'art moderne, Centre Pompidou

Futurism initiated a cult of the machine which fueled their vision of a new, vitalistic movement. The rapidity of travel in a car, train or aeroplane brought new visual and emotional stimuli. Space and time became variable dimensions: they could become condensed, multiplied, or appear endless. Even though cars had been industrially manufactured by Fiat in Turin from as early as 1899, they remained an expensive luxury. Of the Futurist artists only Marinetti, who came from a well-off family, was able to afford a car at an early date. In other words, he was already motorized prior to the proclamation of Futurism in 1909, so it is not surprising that he attributed a key role to cars in his first manifesto. Marinetti described them as "snorting beasts" with "hot breasts," evoking an odd hybrid – a humanoid sex machine.

In painting, the automobile became a crucial technical motif, which each artist treated in a different way. Luigi Russolo's streamlined car in *Dynamism of an Automobile (Dinamismo di un automobile)* resembles some dream-car prototype of the 1960s rather than actual auto designs of the day, whose bulging fenders and boxy chassis lent them an imposingly stiff appearance. With his aerodynamic vision, Russolo was once again ahead of his time. Here matter and space merge in acute angles that drive uniformly across the surface and dominate the effect. These forms ideally reflect what the Futurist aesthetic understood by "lines of force." "When we speak of lines," wrote Boccioni in his 1914 essay "Pittura scultura futuriste (Dinamismo plastico)," "we mean the directions of the colour-forms. These directions are the dynamic manifestations of the forms, the representation of matter on the path given by the construction lines of the object and its action."

The blue-violet car, the composition suggests, rushes forward with incredible energy and speed. An aggressive red-blue contrast and the fiery yellow traces near the wheels underscore this impression. Every reference to the real surrounding world has been expunged. There are no indications of an actual street scene, neither asphalt nor streetlamps, houses nor passers-by. The picture has become an abstract icon of that universal dynamism demanded by Futurism. Still, Russolo has not abandoned the subject entirely. He has not crossed the borderline to pure abstraction, as some of his painter colleagues did. Russolo remained true to observation and analysis. His vantage point was that of the onlooker who watches the car speed by rather than that of the driver seated behind the wheel.

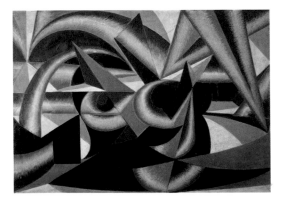

Giacomo Balla, Velocity of the Car, 1910

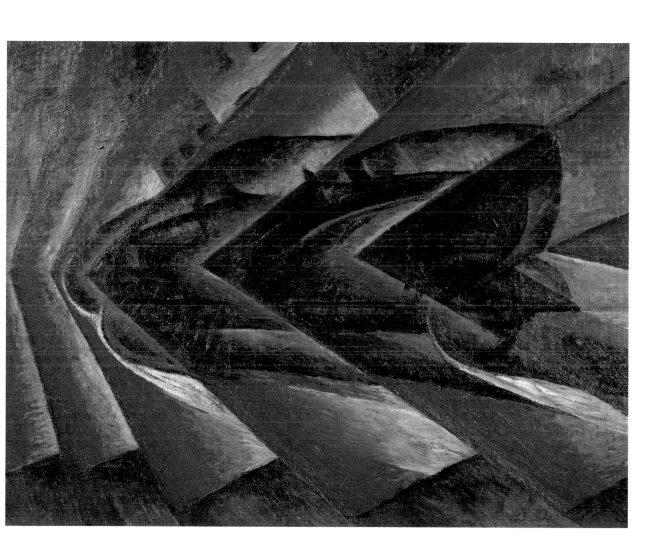

Pictorial Dynamism of the simultaneous Movements of a Lady

Oil on canvas, 86 x 65 cm
Grenoble, Musée de Grenoble

One is tempted to view *Pictorial Dynamism of the Simultaneous Movements of a Lady (Dinamismo plastico di movimenti simultanei di donna)* as a nocturnal scene in which a mysterious female figure moves through a romantically mystical darkness. Other Futurist artists, like Boccioni, usually depicted night life in the big city in ballrooms and scenes inundated by bright electric light. Russolo evidently preferred the public space, on the streets, where only sparing artificial light picked out the contours of people and things.

At the centre of the picture stands a stylized female figure, whose contours are interrupted and certain parts of the body, such as head and legs, repeated to form a fanlike series of after-images. A whitish-yellow ground spreads behind the blue-blacks of the figure, making it stand out and at the same time appear to recede into an increasing darkness. It is not clear whether the figure is caught in that mechanical walking process which was one of the Futurist devices for depicting dynamic movement. The lady holds a book in her hands, and if she is in fact reading, she need not actually be physically moving. Rather than being firmly located in some real place, the figure merges with the atmospheric surroundings, which are defined solely by the distribution of lights and darks. In order to suggest such atmospheric dissolution, Russolo has reduced his palette almost entirely to gradations of yellow and blue-violet. These form both a warm-cold and a complementary contrast, something that for the Futurists was a key means of evoking a dynamic state.

"So there is no yellow or violet," wrote Boccioni in his "Pittura scultura futuriste (Dinamismo plastico)" of 1914, "but only the contrast resulting from them, which forms a mutable and at the same time stable colour entity. This complementarity will not appear in dots, commas and strokes – i.e. means conceived to achieve an objective similarity – but through masses, zones and forms in complementary colours." Moreover, Boccioni speaks of a "light-form," engendered by the indissoluble relationship between light and shadow. For the Futurists, colour had a concrete function, since its optical laws could be exploited to produce certain definite effects. Pure colours possessed an aggressiveness which could be used as a means of revolt against hidebound social structures.

Especially during the emergence of classical modernism, artists attributed symbolic meaning to colours as well. Wassily Kandinsky, thanks to his affinity with music, stood perhaps closest to the ideas of Russolo, who himself turned entirely to music in 1913. In his book "On the Spiritual in Art," published in 1911, Kandinsky described yellow as the typically earthly and blue as the typically heavenly color. This symbolism alluded to both the spiritual and material qualities of his art. Analogous qualities are found in Russolo's atmospheric interplay of coloured forms, which seem to hover between yellow and blue-violet, light and shadow, human figure and space, heaven and earth.

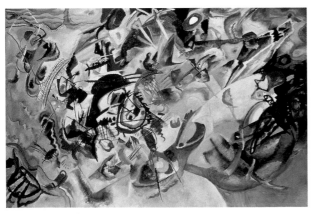

Wassily Kandinsky, Composition VII, 1913

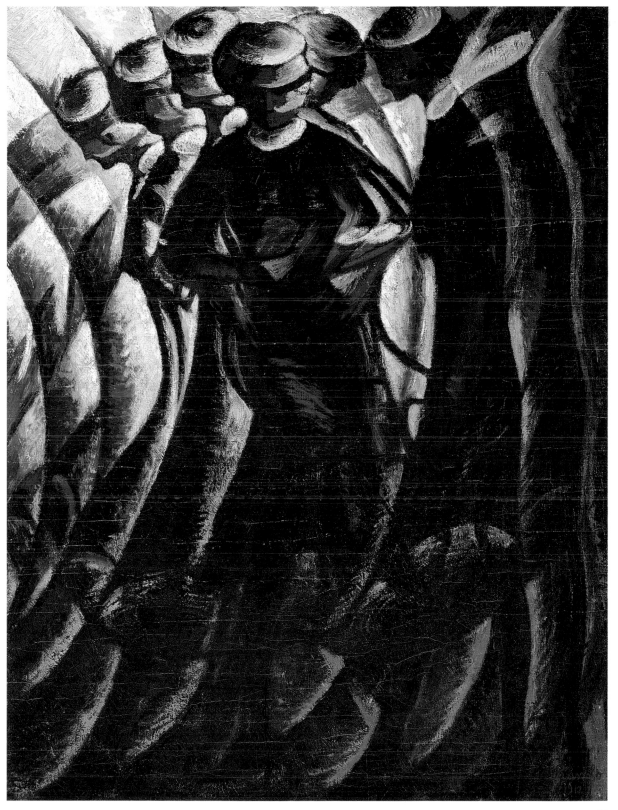

BLue Dancer

Oil on canvas with sequins, 61 x 46 cm
Private collection

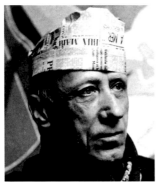

*** 1883 in Cortona,
† 1966 in Paris**

Blue Dancer (Danseuse Bleue) is a major work of Severini's, who devoted many paintings to the world of theatre, dance and night-life in the big city. The ballet impressions of an Edgar Degas (1834–1917) and the acutely observed milieu studies of a Henri de Toulouse-Lautrec (1864–1901) were now superseded by a Futurist view which, in Severini's case, would have been unthinkable without the French Cubism of Pablo Picasso and Georges Braque.

Unlike his ballroom scenes, in which the turbulent events flow across the entire picture with an all-over, undirected energy, here Severini has concentrated on a single, main figure. He has reduced the palette to blue and whitish-gray values and underlain the depiction with a dominant, triangular composition that culminates in the dancer's head and swings out in the area of the dress. In this lower quarter of the picture the figure is divided into countless small segments of form, geometric parcels – arcs, angles, parabolas – that engender dynamic micro-states. Passages of colour are used to blend the female figure into the background. Portions of it, such as arms and head, appear multiplied and depicted in varying perspectives. Only a few props and other, smaller figures suggest the location of the scene.

Severini ideally utilized the means of the Futurist aesthetic to create pictorial correspondences for the movement and energy of the dance. Yet the vitality of these movements is counteracted by the solidity of the triangular composition and the blocky distribution of the two colour values. Harsh colour contrasts, which might have lent the painting a compelling energy, have been entirely avoided.

According to Wassily Kandinsky in his famous book "On the Spiritual in Art," published in Munich in 1911, the triangular form was best suited to schematically representing the spiritual life. In addition, Kandinsky considered blue – as did Franz Marc, his friend and confrere in the Blauer Reiter group – the colour most adequate to conveying spirituality. In view of this symbolism, which was certainly known at the time, Severini's interplay of form and colour takes on an expanded meaning. In *Blue Dancer* he may well have wished to allude to a "spiritual" realm, by translating simple dancing movements into a transcendental event, a universal dynamism in which all sense impressions intermerge. This aspect is underscored by the application of shimmering sequins, which heighten the impression of dematerialization and spirituality.

With the emergence of the collage technique in Cubism, the formal possibilities of art were considerably expanded. The Futurists adopted this method without delay. In 1912–13, for instance, Boccioni integrated a section of window frame in his sculpture *Unification of a Head and a Window.* Beyond this, in a conversation with Severini the French art critic Guillaume Apollinaire pointed out that the old Italian masters had integrated real objects such as keys and precious gems in their depictions of saints. Severini was inspired to emulate them, although this ran counter to the Futurist doctrine of the jettisoning of every tradition.

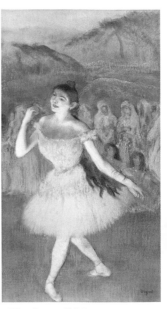

Edgar Degas, Pink Dancer

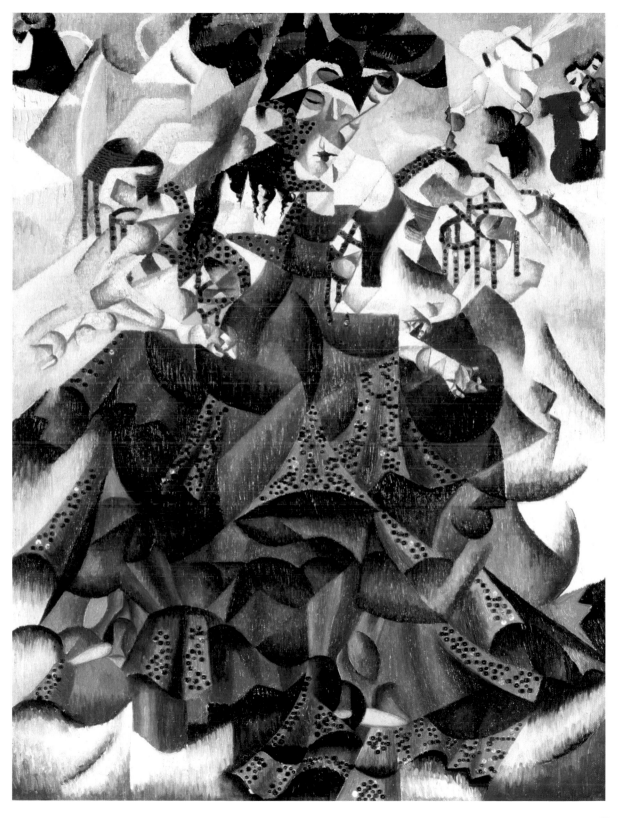

self-portrait

Oil on canvas, 55 x 45 cm
Private collection

Although Severini, who lived in Paris from 1906 onwards, was involved in an active exchange with the art scene there and especially with the Cubists, he remained a Futurist through and through. In his 1913 manifesto "The Pictorial Analogies of Dynamism," Severini reiterated the key points of the Futurist agenda. He viewed the principle of simultaneity of various sense impressions, such as sounds, odours, tones, heat and speed, as means adequate to depict in art the changes in reality brought about by technological progress. Yet he also stated there, "So we must, as we already did with the nude in our first manifesto of Futurist painting, expunge the human figure, still-lifes and landscapes as centres of emotion." In Severini's eyes, human beings were worthy of representation in art only when they could be placed in a larger context, such as "Aeroplane in Flight + Man + Landscape."

Under this premise, how can a Futurist self-portrait be explained? Portraits, especially self-portraits, were in fact a marginal genre in Futurism. Boccioni's mother sat to him for a few paintings and one sculpture. But he merely used her appearance to exemplify

elemental phenomena such as "matter" or "horizontal volumes." The Cubists, with whose works Severini was familiar, frequently employed the human figure and the portrait to explore and test their aesthetic ideas. Juan Gris and the Orphist Robert Delaunay made self-portraits, and in numerous paintings, drawings and sculptures the young French avant-garde focussed on the human head, if usually in an anonymous rather than individual way. Only the German Expressionists – Max Beckmann, Ludwig Meidner, Ernst Ludwig Kirchner and many others – devoted themselves to an intensive analysis of their own appearance. In a dialogue with themselves they inquired into the role of the artist in society, their own state of mind, and their creative potentials.

This is the historical context in which Severini's *Self-portrait (Autoritratto)* emerged in 1912. It is a bust depicted in three-quarter profile. The artist is clad in an ordinary business suit, tie, hat and glasses. The face area in particular is fragmented into multiple facets, facial features like nose and eye are repeated, and the perspective vantage point changes continually. Yet there are no indications of an actual place or a particular time. The Futurist Severini has not woven his figure into a dynamic force field as he did in his numerous depictions of female figures from the dance and theatre milieu. He has concentrated on himself, that self which Futurism, at least theoretically, had shifted out of the centre of interest.

With his left eye, one of the few organs of sight to appear whole in an otherwise completely fragmented composition, Severini explicitly establishes a mental connection with his inmost self. This penetrating gaze with which the artist fixes himself lends his self-portrait, beyond all its formal virtuosity, the character of a self-examination. It manifests that critical and reflective distance the artist maintained with respect to himself and his work.

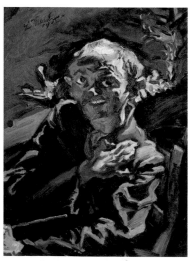

Ludwig Meidner, Self-portrait, 1912

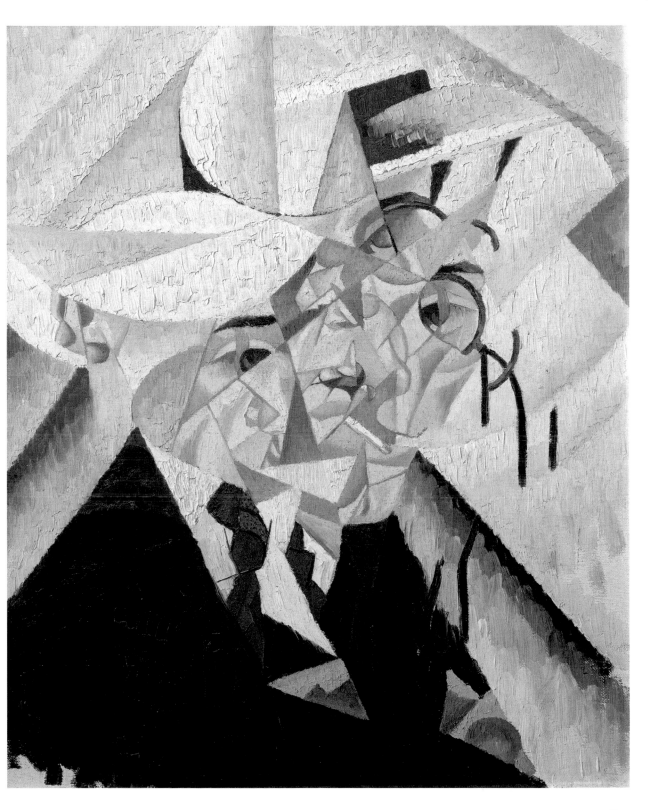

mercury passing Before the sun as seen Through a Telescope

Tempera on paper, mounted on canvas, 138 x 99 cm
Venice, Peggy Guggenheim Collection – The Solomon R. Guggenheim Foundation, New York

Giacomo Balla's painting *Mercury Passing Before the Sun as Seen Through a Telescope (Mercurio passa davanti al sole visto dal cannocchiale)* was inspired by a natural spectacle in 1914. It was one of a series of works on paper devoted to his observation of a partial eclipse. The planet Mercury, closest to the sun, can be seen passing across its surface as a small dark disk at irregular intervals. This is the only point in its orbit that Mercury is visible from Earth.

The painting is yet another example of Balla's interest in scientific phenomena, which was typical of his first Futurist period. Previously he had used a rigorously analytic approach to segment motion sequences, such as a dog's gait or a speeding automobile, and, in *Iridescent Interpenetrations,* 1912–13, he devised systems of order for the colour spectrum. In *Mercury Passing Before the Sun,* the universal dynamism that was of key import for Futurism is combined with a cosmological symbolism. The sun and Mercury appear as signs – discs and stars, interwoven into a dynamic constellation of colour and form. Balla has condensed the spectacle of an eclipse into a cosmological vision of nature. Its basic underlying geometry is reflected in the forms of circle, arc, vortex and plane surface. The essential vitality of nature is evoked by the forcefield produced by these formal elements – especially the vortex as a dynamic process – and their mutual interpenetration.

In addition, continuing his previous analyses of mechanical motion, Balla has rendered the surfaces of the forms here as being transparent. Planes and volumes are evoked by thin black, blue and green hatching that suggests the three-dimensionality of the forms and lets the yellowish-brown ground shine through over the entire picture surface. Bright white rays emitted by the star at the upper left corner overlay and penetrate the composition from edge to edge. These emphasize the complete interpentration of all the elements, and their intense brightness underscores the impression of light refracting through a crystal.

The crystal, a basic component of nature with an elementary geometric structure and a transparency that conveys the idea of immateriality, plays both a structural and metaphorical role in Balla's depiction of Mercury's passage. A long-standing subject in the history of art, the crystal's essential content and transparency were often used by artists at the start of the twentieth century to visualize a usually pantheistic view of the world. Erich Heckel, for instance, plunged one of his bathers in a facetted landscape in *The Crystal Day,* 1913, thus evoking the unity of man, nature and the cosmos. The Russian Futurist David Burliuk turned to atoms as the building blocks of crystals in 1916, and architects like Bruno Taut and Hans Scharoun designed glass architecture modelled on crystalline structures. Almost always the subject of crystals brought a touch of romanticism into art, and Balla's is no exception. Despite the clearly scientific interest reflected in *Mercury Passing Before the Sun,* the image is certainly not without a air of dreamy idealism.

Erich Heckel, The Crystal Day, 1913

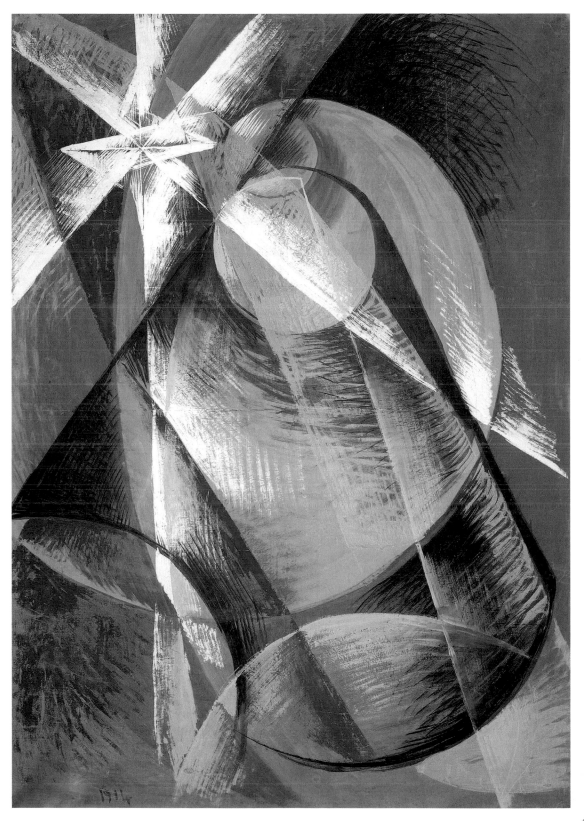

Long Live Italy

Oil on canvas, 36 x 47 cm
Private collection

Long Live Italy (Viva l'Italia), done in the context of the Futurists' enthusiasm for war, clearly reflects their patrotic attitude. They had long advocated that Italy enter the war, and their public proclamations and numerous publications contributed to the widespread nationalistic fervour. In the Futurists' eyes, Italy deserved to stand at the forefront of the European nations both politically and culturally. In May 1915, Italy declared war on Austro-Hungary. Many Futurist artists volunteered for service. In their art, this enthusiasm took the form of an idealization of the dynamics of battle and a joyous riot of colour. *Long Live Italy* holds a special place among these propaganda paintings, being what is known as a *sbandieramenti,* literally a "flag-waving picture."

To welcome the war, Balla employed a pictorial formula that is abstract in a dual sense. The sequence of green-white-red echoes the colours of the Italian flag. At the same time this triad, supplemented by blue-violet and orange, forms a dynamically interwoven composition which is entirely without reference to real objects. The rectangular flag is not present in its usual form. Instead, its colours appear in expanding arc segments which converge dynamically towards the centre, convincingly visualizing the waving of a flag.

Long Live Italy was one of a series of non-objective compositions done in the context of Futurism. In 1912 Balla himself had devised purely geometrical colour systems in his series of *Iridescent Interpenetrations,* and in 1913–14 Umberto Boccioni and Gino Severini arrived at a cosmological abstraction in which hatched brushstrokes suggested the interpenetration of the separate compartments of the composition. Now, in *Long Live Italy,* Balla used compact pictorial forms to create an entirely non-objective visual syntax. Together with his younger colleague Fortunato Depero, he developed a new definition of Futurist dynamism in the manifesto "La ricostruzione futurista dell'universo" (The Futurist Reconstruction of the Universe), which was published in parallel with Balla's 1915 paintings. Here the two artists, who formed the phalanx of the second phase of Futurism, proclaimed an art based on "plastic complexes." Operative terms such as abstract, dynamic, extremely colourful, intensely brilliant, autonomous, rotation, and disassembly marked out new guidelines for their artistic activity.

But it was above all the third dimension, the suggestion of volume on a flat plane, that became the basis of Futurist dynamism. This reorientation had been anticipated in Balla's art early on. In 1912, he had decorated the Düsseldorf residence of the lawyer Arthur Löwenstein with ornamental friezes, murals and ceiling paintings. Balla's designs for interiors combined murals, three-dimensional objects and furniture into a geometric, ornamental unity. Plane and space entered a compelling dialogue. In parallel the artist also concerned himself with men's fashions, and designed suits for his own use.

About 1915, Balla's penchant for massive volumes came powerfully to the fore in a work like *Long Live Italy.* And to further increase the plastic quality of his painting, he added a painted frame to it. This lent the work of art the character of an object in its own right.

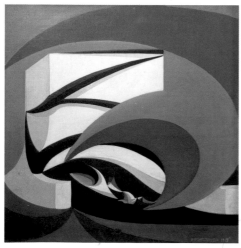

Flags on the Altar of the Fatherland, 1915

Futurist Life

Film stills
Whereabouts of film unknown

A few remarkable films were produced in the context of Futurism, only one of which has survived: *Thais*, made by Anton Giulio Bragaglia in 1916. Futurist experiments in the fledgling motion picture medium marked one point in the expansion of the film business from 1900 onwards. Other coordinates at this early date were the French genre of the crime film *(Fantomas)* and the American slapstick comedy – on celluloid, Charlie Chaplin's characters outpaced even the latest modern machines. In the late 1910s, Hans Richter and Viking Eggeling among others established the "absolute film," and in Expressionist cinema, the camera pan became an integral part of film dramaturgy. Futurism was the first art movement, even before Expressionism and Surrealism, to explore the potentials and aesthetic status of the film.

The brothers Arnaldo and Bruno Ginanni-Corradini, of Florence, in 1911 produced four abstract short films aimed at a synaesthetic experience analogous to current advances in painting. Yet they were unable to establish a link with the doctrinaire Futurist group. In 1916, however, immediately after the death of Umberto Boccioni – who had refused to consider either photography or film as legitimately belonging to art – a unique and productive collaboration came about. Filippo Tommaso Marinetti, Emilio Settimelli, Arnaldo and Bruno Ginanni-Corradini – who now went by the futuristically abbreviated names of Ginna and Corra – and Giacomo Balla joined forces to produce a film, and by so doing they finally established the aesthetic autonomy of the new medium within the Futurist movement.

This film, *Futurist Life (Vita futurista),* has apparently not survived. At best, it can be reconstructed on the basis of individual stills and literary references. *Futurist Life* consisted of several unrelated

Futurist Life, 1916

sequences in which the Futurists acted out their lives on a second, cinematic level of reality. Some sequences showed them dining at the Ristorante del Piazzale Michelangelo in Florence, sleeping, or out for a walk. Others featured quite absurd and unreal confrontations, such as a discussion among a foot, a hammer and an umbrella, or the dance of a female apparition during Balla's betrothal with a chair. This last episode reflected the Futurists' aesthetic idea of a universal transparency and interpenetration of all things, and in addition suggested the movement's link with parapsychology and the cult of spiritism, which had begun to flourish around 1900.

In terms of structure, the film followed the numerical order familiar from variety shows and the Futurist soirées rather than relying on the epic narration which began to predominate in feature films around 1915. With its performance approach and surreal elements, *Futurist Life* anticipated the coming idioms of Surrealism, and the much later performance art. In their manifesto "La cinematografia futurista," likewise dating to 1916, Marinetti, Corra, Settimelli, Balla, Remo Chiti and Ginna defined Futurist cinema, by reference to *Futurist Life,* as a "poly-expressive symphony" and "reality rendered chaotic." It was to function as an "alogical and fleeting synthesis of the life of the world." *Futurist Life* was screened on 28 January 1917 at the Teatro Niccolini in Florence, as one point in the programme of a Futurist soirée.

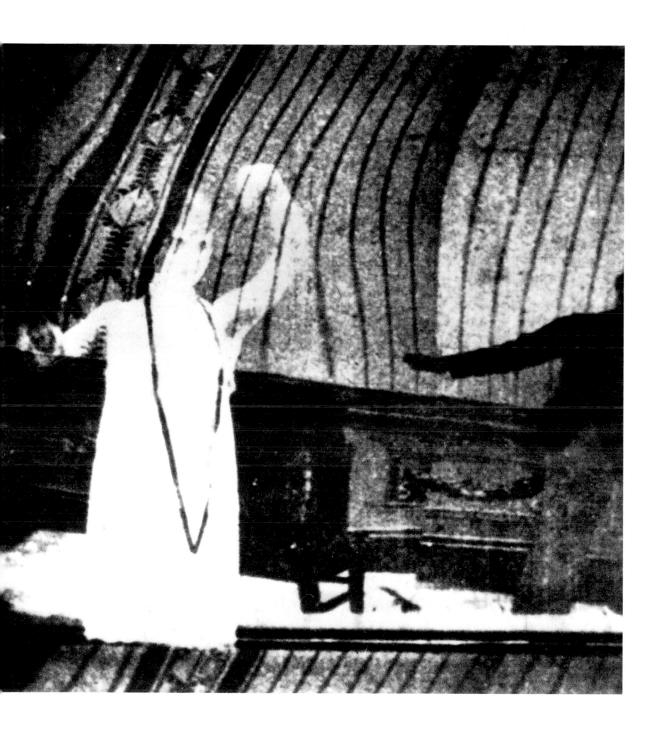

ınterventionist ℳanifestation

Collage on cardboard, 38.5 x 30 cm
Venice, Collezione Gianni Mattioli,
Peggy Guggenheim Collection – The Solomon R. Guggenheim Foundation, New York

On 1 August 1914, the collage *Interventionist Manifestation (Manifestazione intervenista)* was published in the journal "Lacerba" under the title *Patriotic Festival (Festa partriottico-dipinto parolibero).* That year Carrà was exploring the potentials of this new technique, introduced by the Cubists Pablo Picasso and Georges Braque in Paris, and in the present work he arrived at an original variation of collage.

In the process Carrà completely relinquished reference to actual things. "I have suppressed every representation of human figures," he explained, "in order to depict the pictorial abstraction of urban tumult." Various newspaper clippings, labels, tickets and other typographical fragments have been arranged into a composition that appears virtually to rotate and whose forces seem to stream both towards the centre and to the picture edges and beyond. In the abstract structure of a rotating disk, likely familiar to Carrà from the *Disques* and *Formes circulaires* done by French painter Robert Delaunay from 1912 onwards, the Futurist dynamically evoked the tumultuous events that shook Italy in 1914. Reality confronts the viewer in the shape of authentic fragments and a linguistic kaleidoscope: *RUMORI, STRADA, SPORTS, TOT, Noi siamo la PRIMA,* and at the hub of it all, *ITALIA.*

It was the period just prior to the First World War, when Italians were divided into neutralists and interventionists and the mood was at fever pitch. With *Interventionist Manifestation* Carrà added his voice to the Futurist paean on the glories of war, and demanded that Italy enter it, which it in fact did in 1915. Here collage became an instrument of propaganda. It combined agitational language like that used in the written Futurist manifestoes and, orally, at their soirées, with an aesthetic that condensed the image into visual poetry.

The ground for Carrà's collaged word-pictures had been prepared by Marinetti's *parole in libertà* and *tavole parolibere,* or liberated words and syntax. The writer exploded traditional grammar, condemned adjectives and adverbs, adopted a telegram style, introduced mathematical symbols into texts, created onomatopoetic linguistic montages, and proclaimed a free typography. Carrà's collage contains an explicit reference to these innovations: a narrow strip of paper pointing to the upper left corner and bearing the echoic words "Zang [Tu]mb Tuum," the title of a 1914 novel by Marinetti. It described his experiences during the Italian siege of Hadrianople in a language that was radically liberated, in both a semantic and a typographical sense. The book amounted to a visual and acoustic experience whose tone was set by violence, aggressiveness and dynamism.

In *Interventionist Manifestation,* Carrà brought fragments of reality, "liberated words" and visual art into an unprecedented synthesis. This form of collage was unknown to Cubism. Not until Dadaism in the 1920s would word-collages of this type again be taken up and modified to suit the Dadaists' purposes. Carrà continued to experiment along these lines in the context of Italian militarization, in 1914 producing a work on paper called *Pursuit* and in 1915 publishing a book in Milan, "Guerrapittura," a record of his war experiences in drawings, collaged elements and "liberated words."

"ꜰuturism, as a rebellion of life, intuition and feeling, as a stimulating and stormy spring, declares merciless war on that doctrine, those individuals, those works which repeat the past to the detriment of the future, keep it alive and celebrate it."

Francesco Balilla Pratella

67

Bird's movement

Oil on canvas, 100 x 130 cm
Rovereto, Museo d'Arte Moderna e Contemporanea di Trento e Rovereto

* 1892 in Fondo,
† 1960 in Rovereto

Fortunato Depero was the main motive force behind the second wave of Futurism, which began to gather momentum around 1915–16. In 1915 he co-authored, with Balla, a manifesto titled "The Futurist Reconstruction of the Universe," which set forth theoretical premises for a revival of Futurism. Now the vitalistic Futurist philosophy was to encompass every field, not only of art but of everyday life as well. With this aim in mind, Depero developed into a true modern Renaissance man, devoting himself to painting, design, sculpture, graphic art, illustration, interior design, stage design, ceramics and writing. As early as 1927, at age thirty-five, he published "Depero Futurista," a review of his oeuvre, including literature, from 1913 to 1927. Since the cover and pages were not conventionally bound but held together with bolts, the volume became known as a *libro bullonato,* or bolted book. Published by Dinamo-Azari in Milan, it is considered the first book-object ever.

Bird's Movement (Movimento d'uccello) was executed a year after the appearance of the first manifesto of Secondo Futurismo, and clearly reflects its new aesthetic approach. A large, nearly circular form, slightly shifted away from the centre of the horizontal format, unfolds against a monochrome ground. Large-area, fanlike segments interlock in a spatially indeterminate context. Smaller geometric elements spread from the centre outwards and stand in sharp contrast to the interrupted disc. This abstract constellation of form is dominated by a colour triad in red, blue and yellow. Black and white serve to emphasize the brilliant colour values by contrast, and a potpourri of lighter tones mitigates the rigour of the three-part colour chord.

The point of departure, the motif of a bird's flight, has been reduced to an abstract pattern of movement. Depero's confrere, Giacomo Balla, had in a 1913 painting divided the flight of a bird into individual segments in order to evoke its motion. This type of analysis was typical of early Futurism. Depero, in contrast, has synthesized a range of pictorial elements into a far more complex idea of motion. Although the circular form does evoke a sense of rotating motion, the dynamism of the composition remains relatively subdued.

Depero's aim was to overcome or further develop the mere suggestion of movement characteristic of earlier Futurist painting. In the manifesto "The Futurist Reconstruction of the Universe," he and Balla explained: "We will give flesh and bones to the invisible, the ineffable, imponderable, non-perceptible. We shall find abstract equivalents for all the forms and elements in the universe, then combine these in accordance with the whims of our inspiration to form pictorial complexes which we set in motion." Such pictorial complexes, according to the authors, would turn on one or more pivots and engender a rotation. They could appear in the form of segmented cones, pyramids or spheres. Depero and Balla demanded a pictorial autonomy which would encompass all aspects of reality. *Bird's Movements* shows how such a construction, both autonomous and related to reality, might look.

In subsequent years Depero not only continued to develop a rigorously abstract, non-objective form of painting, but devoted himself in parallel to narrative depictions in which dehumanized, mechanical creatures populated stagelike scenes. The reduced visual language employed in *Bird's Movements* underwent a modification in the early 1920s when Depero turned to advertising and designed playful billboards in brilliant colours for companies such as Campari and San Pellegrino.

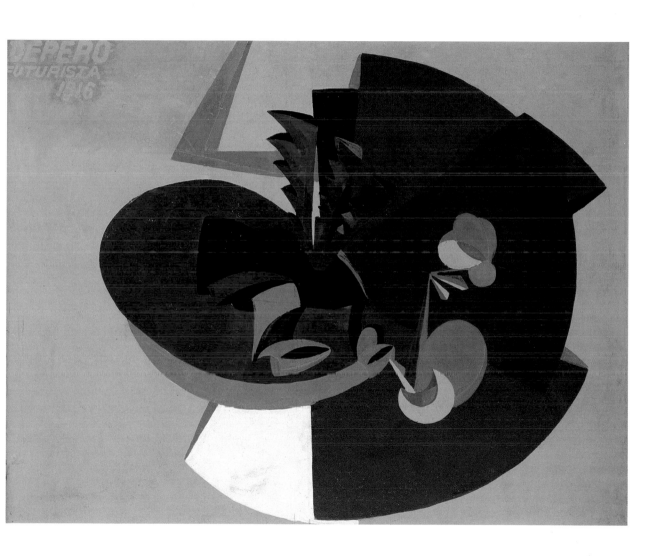

Mechanics of Dancers (Mechanics of Ballerinas, Ballerina + Idol)

Oil on canvas, 75 x 71.3 cm
Trento, Museo Provinciale d'Arte

Around 1917, when *Mechanics of Dancers (Mechanics of Ballerinas, Ballerina + Idol/Meccanica di ballerini (Macchinismo di ballerini, Ballerina + Idolo)* was executed, Depero's art was dominated by the realm of theatre, music and dance. Back in 1916 he had created a ballet, "Minismagìa," and designed costumes for the actors which could be rapidly altered with a few manipulations. This piece marked the first time in which the protagonists were turned into marionettes on stage. Just a year later Depero was commissioned by Sergei Diaghilev, head of the Ballets Russes, to design a stage for "Le Chant de Rossignol" (Song of the Nightingale, music by Igor Stravinsky), which proved to be spectacular. The stage was inhabited by abstract, geometric forms, thorny metal flowers, and figures of wood and sheet metal. Yet Diaghilev apparently thought this brightly coloured fantastic scene too dominant for the vital weightlessness with which he envisioned his dancers performing. So in 1920 he asked Henri Matisse to provide a more classical design. Still, Depero's project would be realized in 1981, for a Venice performance of the ballet in the original choreography by Léonide Massine.

In 1918 Depero's involvement with dance theatre culminated in his "Balli plastici," five musical farces in mime in which mechanical figures – harlequins, jumping jacks, hybrid creatures, half human, half insect – moved around the stage to a musical accompaniment (by Béla Bartók, among others) and embodied various themes (e. g. *I selvaggi,* The Furious Ones). In this case, too, it was not human beings but marionettes who acted in a magically surrealistic scene.

Giorgio de Chirico, Hector and Andromache, 1924–25

In *Mechanics of Dancers,* Depero recurred to this realm of mechanized dolls and placed two of these in an indeterminate geometric space. The figures are even more strongly abstracted than in Depero's costume designs, looking only vaguely human. The left-hand, male figure consists solely of grey, metallic tubes and boxes, and the right-hand, female one of colourful cylinders, a lace-trimmed skirt, and a double star as headdress. A third, female figure in a tambourine-like circle at the right plays a secondary, undefined role. The elements of the two marionettes interlock in a dance movement that suggests a pas de deux.

Hybrid machine-human creatures in many forms played a key role in early twentieth-century art. Giorgio de Chirico, founder of Pittura metafisica, or Metaphysical Painting, employed the *manichino,* or mannequin, as a stand-in for human figures; the Surrealists integrated window dummies in their imagery; and in 1926 Fritz Lang made the film "Metropolis," which featured a female humanoid machine.

Among the Futurists, Marinetti in particular advocated from the start that human beings be "improved" in the direction of machines. "The point," he once explained, "is to prepare the ground for the imminent identification of man with machine by furthering and perfecting a continuous exchange of intuition, rhythm, instinct and metallic discipline." Marinetti later translated his notion of a superhuman mechanical creature into an actual metal construction. Depero, by contrast, invariably conceived mechanized man in the form of a marionette. Although activated by strings, it always seems to possess a certain playful independence with respect to reality. In this regard, at least, the marionette might be considered superior to man.

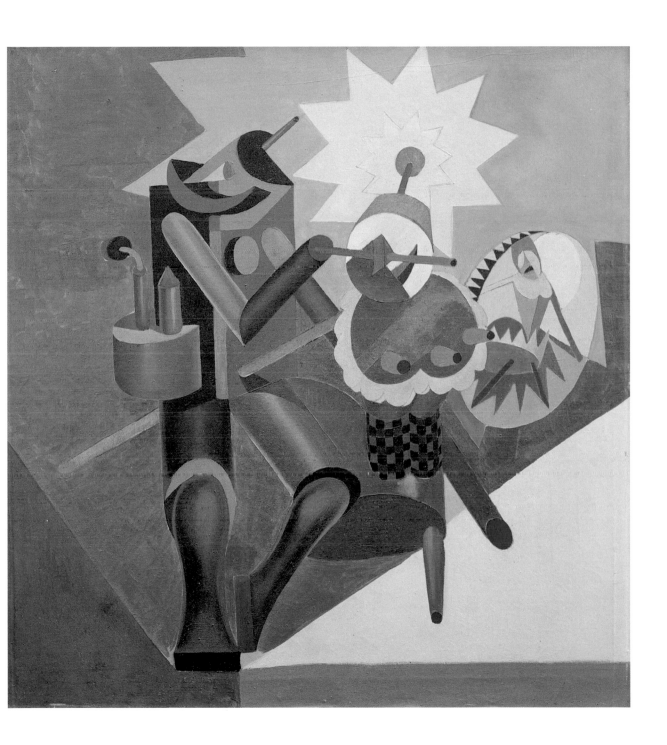

construction of a Little Girl

Lacquered wood, 41 x 21 x 14 cm
Rovereto, Museo d'Arte Moderna e Contemporanea di Trento e Rovereto

The small wood sculpture *Construction of a Little Girl (Construzione di bambina)* can be viewed in the context of the ballet and stage designs to which Depero intensively devoted himself in the years 1916 to 1918. It represents a translation into sculpture of that mechanical being which appeared in many of the artist's paintings and stage productions.

In an additive way Depero has combined various wooden elements, such as discs, squares, cylinder, a triangle, and spiral columns, into an abstract figure. The colors red, blue and yellow form a strong triad that lends the piece a joyous, colourful effect. The girl in her blue and red skirt stands on only one leg, a feature Depero frequently used in his art to suggest rotating movement. This aspect is augmented on a metaphorical level by the spiral columns, which implicitly bring dynamics and motion into *Construction of a Little Girl*. Yet these are present only as abstracted, encoded values. Boccioni, who had already begun experimenting in the field of sculpture in 1912–13, had broken sculptural volumes open by fraying their contours, thus visualizing an interpenetration of matter and surrounding space and evoking forms in continual motion. By conveying an impression of something fleeting, in the process of dissolution, Boccioni suggested movement in the actual third dimension. In the case of Depero's piece, in contrast, the viewer is forced to decode its dynamic content: one leg + spiral columns = rotating movement.

Although Depero, representative of Secondo Futurismo, and Boccioni, a leading protagonist of the first Futurist wave, pursued similar aims, the means they used were quite different. Depero's *Construction of a Little Girl* gives the impression of having been assembled of children's bulding blocks. It lacks the conceptual depth that underlay the works of Boccioni or the sculptures of French Cubism. Depero evidently placed great store in playful insouciance. In the manifesto he co-authored with Balla in 1915, "The Futurist Reconstruction of the Universe," he advocated Futurist toys which would give children the opportunity to develop their talents in an untrammeled way – if within the context of the Futurist value system. Depero and Balla declared play and the play instinct – for adults as well as children – to be a fundamental aesthetic strategy of Futurism. Seen in this light, *Construction of a Little Girl* is not only a three-dimensional symbol of movement but demonstrates the new theoretical thrust that Futurism now took.

In the following years Depero concerned himself intensively with the medium of sculpture. In 1919 he furnished the Casa d'arte in Rovereto with utilitarian and decorative objects, and created, as at the Monza Biennale in 1923, elaborate exhibition installations containing sculptures, wall hangings and furniture. Movement and play were the two essential elements that recurred again and again in these works and installations.

Model for Pinocchietto, 1917

Elegant speed
– Liberated words (1st Record)

Collage and ink on paper, 53 x 26.5 cm
Private collection

* 1876 in Alexandria (Egypt),
† 1944 in Bellagio

Emilio Filippo Tommaso Marinetti was the founder and leader of the Futurist movement, the man whose enthusiastic pronouncements and provocative public appearances swept all of the others along in his wake.

The "liberation of words" was Marinetti's revolutionary achievement, whose effect far outlasted the movement itself. The writer declared conventional syntax and grammar invalid in a series of manifestoes, beginning in 1912 with the "Manifesto tecnico della letteratura futurista" (Technical Manifesto of Futurist Literature), and followed a year later by "Parole in libertà" (Liberated Words).

With such steps, which were accompanied by many other activities and publications, Marinetti soon moved in the direction of a visual poetry, as seen in *Elegant Speed – Liberated Words (1st Record)/ Vitesse elegante – Mots en liberté (1er récord)*. With complete syntactic abandon Marinetti cast letters, mathematical symbols – especially vectors, which indicate directions of force – words, semantic abbreviations, objects and sentence fragments onto the sheet of paper. The typography changes abruptly but continuously. The author writes, draws, cuts and pastes. We as readers can now no longer follow a consistent text word by word and line by line. Instead, our eye and mind are inundated by diverse set pieces of content, in word and picture. We are confronted with a visual text which opens a wide field of potential combinations and mental associations.

Yet Marinetti does provide a mental context, defined by the vitalistic philosophy of Futurism. It is a sort of manufacturers' fair that includes most every technological advance of the period. Cars, airplanes, ships, zeppelins and a train represent the potential energy of Italy, which also includes horsepower. The aim is to set records, to become the number one and conquer new terrain. The repetition of the word MOI (French, me), draws both author and reader into the midst of the dynamic happenings.

Among Marinetti's painter colleagues, Giacomo Balla, Carlo Carrà and Gino Severini in particular likewise experimented with word pictures around 1913–14. They integrated letters, words and numbers in their paintings or constructed compositions in collage.

Marinetti's advance to the linguistic picture would become a key source for the Dada movement, which came immediately in the wake of early Futurism, as well as for the visual poetry of the 1960s. He himself was able to take a cue from early attempts at "liberating words" made by French litterateurs such as Alfred Jarry and especially Stéphane Mallarmé. Marinetti already recited pieces by both authors at his early lecture evenings, which prior to the founding of Futurism in 1909 anticipated the famous *serate futuriste.* Mallarmé wrote his work "A Cast of the Dice Will Never Expunge Chance" in a completely new form: words and word groups freely distributed across the page, some running across the pagefold, and changing line heights, insertions and parentheses that interrupted the syntactical flux. The book was published in 1897 and 1914 in quite different typographical versions. Mallarmé's innovative approach to the printed text provided key stimuli to Marinetti.

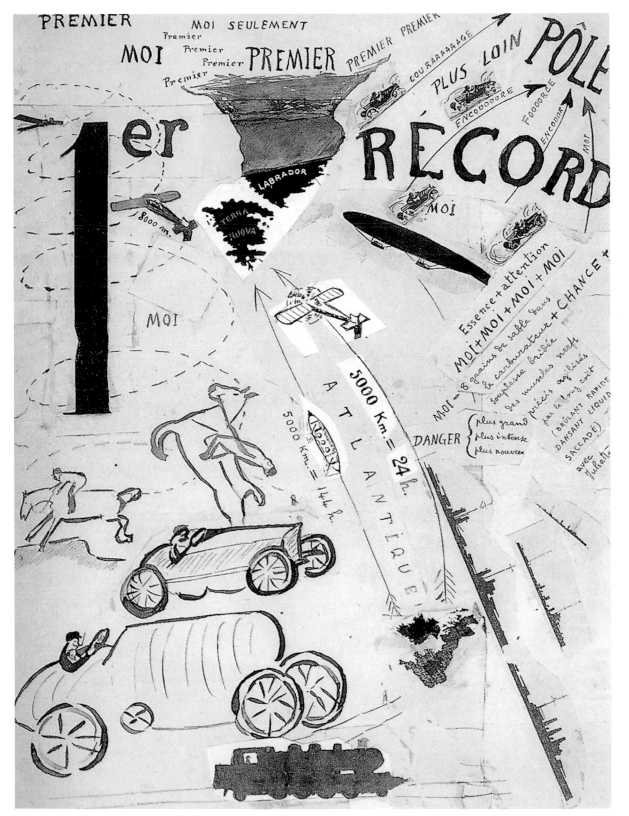

Electric Power plant

Ink and pencil on paper, 31 x 20.5 cm
Private collection

* 1888 in Como,
† 1916 in Monfalcone

Antonio Sant'Elia was the leading architect of Futurism. He joined the Italian avant-garde rather late, in 1914. In 1915 he volunteered for service in World War I and was fatally wounded in October 1916. In other words, the period of his active participation in the Futurist movement was brief. Still, his designs came to represent the quintessence of a futuristic architecture in which technical advances and a dynamic sense of form entered a visionary synthesis.

In his manifesto "L'Architettura futurista" (Futurist Architecture), edited by Marinetti and published on 1 August 1914 in the journal "Lacerba," Sant'Elia proclaimed a new conception of residential building and urban planning along Futurist lines. He advocated the employment of modern building materials such as reinforced concrete and iron, rejected every form of ornament, and predicted that buildings would have only limited durability. For him, the building was a machine and the city a huge construction site. "We have lost the sense," wrote Sant'Elia, "of the monumental, the weighty, the static and charged our sensibility with a sense of lightness, practicality, transitoriness and rapidity."

However, the architect was able to do no more than express his ideas in drawings which were never put into practice. It was not until the 1960s, when individual architects and groups like Archigram, Hans Hollein and Raimund Abraham adopted and reinterpreted a futuristic, visionary approach, that the technical and social conditions became ripe for a partial realization of such plans.

Electric Power Plant (Centrale elettrica) emphasizes the dynamic nature of the building and its purpose. Like almost all of Sant'-Elia's drawings, this is a perspective rendering rather than a precise construction blueprint. Power lines, stacks, pillars and banks of insulators tie the *Power Plant* into a network of lines and soaring building volumes. Viewed from a low vantage point, the building with its vertical and diagonal elements rises in front of a massive dam. A stark contrast between horizontals and verticals lends Sant'Elia's structure a sense of extreme dynamism.

In addition to railway stations and airports, power plants were one of the urban nodes of energy on which Sant'Elia focussed. The growing, technocratic industrial city was the point of departure and culmination of the Futurists' philosophy of life, and accordingly, Sant'-Elia's designs issued in a grand urban vision: *La città nuova,* or The New City. In face of increasing industrialization, architects from the start of the nineteenth century had devoted themselves to a reform or systematization of urban planning. Their utopian models ranged from the revolutionary architecture of the Frenchman Etienne-Louis Boullée (1728–1799) to the designs of the Arts and Crafts movement in England, based on the theories of John Ruskin and William Morris. One modern urban planning scheme was actually put into practice in Paris, in 1900. Under the supervision of Georges Eugène Haussmann, massive interventions in the form of broad boulevards and new districts were made in the dense building structure that had proliferated uncontrolled in the French metropolis since the Middle Ages.

Similar if much less efficient approaches were adopted in Italy as well, especially in Rome and Florence. Yet in general a traditional understanding of architecture and urban planning predominated, as exemplified by the pompous, eclectic cake-frosting style of the *Vittorio Emanuele II Monument* at the centre of Rome (1885–1911). It was not until the 1930s that an innovative rationalism came to the fore, especially in northern Italy. Furthered by the fascist regime, it brought forth a modern architecture such as that seen in the railway stations in Florence (Santa Maria Novella, by Giovanni Michelucci, 1935) and Rome (Stazione Termini, by Angelo Mazzoni, 1938).

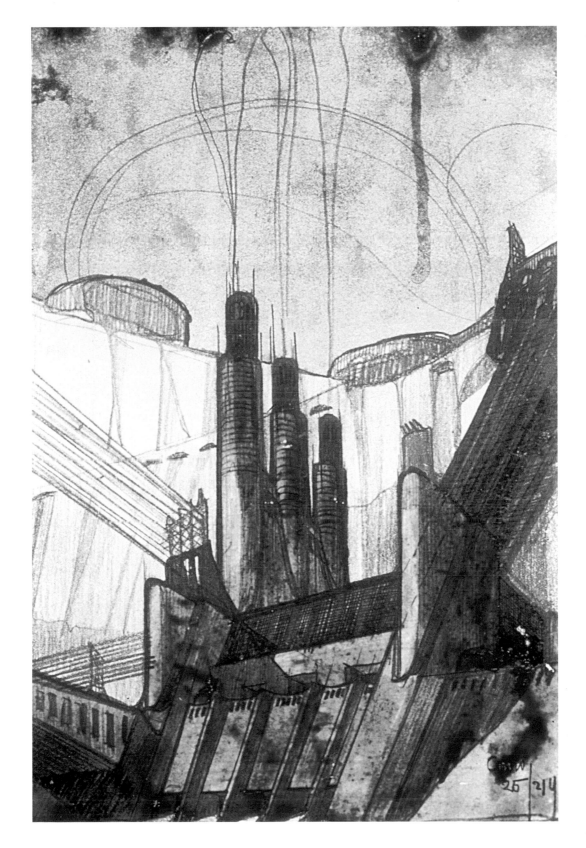

spherical EXPANSION of Light into space

Oil on canvas, 62 x 50 cm
Private collection

One of the peculiarities of Futurism was the fact that nearly all of its representatives bolstered their art by theoretical considerations, in the form of manifestoes. Practice and theory were mutually supportive as in none of the other "isms" of classical modernism. Boccioni, for example, defined categories that took on key significance for the entire movement in his treatises. His concept of a universal dynamism in which reality consisted of interpenetrating motions, and the idea of simultaneity, set the standards for Futurist art theory.

Gino Severini moved to Paris in 1906 and, apart from brief visits, did not return to Italy until 1934. He was familiar with the thinking of French artists such as Robert Delaunay, Georges Braque and Albert Gleizes, who contributed to making Paris the key centre of European art in the early years of the twentieth century. Forces gathered momentum and made giant steps towards the development of a non-objective art. Delaunay, who, coming from Cubism, founded Orphism in 1912, created his window paintings and *Disques simultanés,* or *Simultaneous Discs,* an art that poet and art critic Guillaume Apollinaire described as "pure painting." At the same period,

artists like Wassily Kandinsky and Kasimir Malevich developed other conceptions of non-objective art and views of the world.

It was to this choir that Severini added his voice. In his manifesto "Analogie plastiche del dinamismo" (Pictorial Analogy to Dynamism), 1913, he built on Boccioni's ideas to explain that certain colours and forms could convey various impressions and trigger various memories. One and the same arrangement of color and form might just as well be used to depict and arouse the emotions associated with an ocean liner as with the Galeries Lafayette department store. Severini called this process "pictorial analogy." Now, he concluded, objects were no longer required as vehicles of information. Proceeding from this principle, Severini defined an analogy of form and colour. He viewed colour primarily as coloured light, composed of the hues of the spectrum. At the time of writing Severini was aware of Balla's *Iridescent Interpenetrations,* a schematic systematization of coloured light done back in 1912. He was also familiar with the French Neo-Impressionists' employment of the colour spectrum.

Such inspirations informed the completely non-objective "spheric" compositions Severini executed in 1913–14, including *Spheric Expansion of Light into Space (Expansion sphérique de la lumière-centrifuge).* In his manifesto the artist provided a good example of how such a "spheric expansion" could be rendered in a painting: "If the middle of a group of forms is yellow, then the colors moving into space follow from colour analogy to colour analogy, ending with its complementary, blue, and, if necessary, black, the absence of light, and vice versa. Naturally several centrifugal or centripetal cores can stand in simultaneous dynamic contrast in one and the same painting or pictorial complex."

Spherical Expansion of Light into Space appears veritably to illustrate Severini's theoretical explanation. It is a vibrant, rhythmical composition in the colours of light in which arcs, angles, planes and volumes are complementarily juxtaposed. From the whitish-yellow centre to the edges of the picture, a spectrum of yellow through orange and purple unfolds to greenish-blue, blue and blue violet. White and black serve to contain the expanding passages of colour. Here Severini has combined two approaches into one. While adhering to the laws of optics he has redefined the key Futurist idea of universal interpenetration on a non-objective plane.

Robert Delaunay, Circular Forms, 1912

Red Cross Train Passing Through a Town

Oil on canvas, 88.9 x 116.2 cm
New York, The Solomon R. Guggenheim Museum

In May 1915 Italy declared war on Austro-Hungary and in August of the following year on Germany. The Futurist artists, above all Marinetti, had not only hoped for this occurrence but had actively demanded it in their statements, manifestoes and art. A glorification of violence and battle was at the bottom of the entire movement, which achieved one of its goals when Italy entered the war.

This heroic view of war and its effects was shared by nearly all Futurist artists, with the exception of the writer Aldo Palazzeschi (1885–1974). Some motifs, like an armoured train or Italian lancers, recurred again and again in their work, the latter personifying the notion of a fearless mounted warrior which was soon destined to be relegated to the junkpile of history by the reality of mechanized war.

In advance of Italy's entry, Marinetti had written to Severini in Paris on 20 November 1914 to suggest how he might best approach war painting: "Boccioni and Carrà agree with me and think that immense artistic innovations are possible. So we encourage you to

interest yourself pictorially in the war and its reverberations in Paris. Try to live the war in pictures, study it in all its wonderful mechanical forms (military trains, fortifications, wounded men, ambulances, hospitals, parades, etc.) … Take advantage of it, join in the enormous anti-Teutonic emotions that grip France."

At the moment Italy entered the war, Severini was in Rome. He immediately returned to Paris, and produced a series of pictures that focussed on the mechanical aspects of war. These were exhibited in January 1916 in Paris under the title "First Futurist Exhibition of Art and War."

Red Cross Train Passing Through a Town (Train de la croix rouge traversant un village) belonged to this series. It shows a supply train flying the French flag and speeding through a cheerfully colourful landscape on the margins of a town. Train, meadows and houses are divided into interpenetrating geometric fragments, façades cutting through the train cars and rooftops merging with the cloud of steam emitted by the locomotive.

Stylistically speaking, Severini was then in a transition phase from a Futurist to a Cubist idiom. At this moment, the clearly elucidated concept of Cubo-Futurism was perfectly suited to the propagation of war from a detached, clinical point of view.

How idealistic this view and the corresponding art were, becomes clear by a comparison with those of the realist Otto Dix, who initially greeted the First World War as enthusiastically as the Futurists. With an undertone of fascination, Dix later admitted, "The war was a gruesome thing, but nevertheless something enormous. I wouldn't have missed it for anything. You have to have seen human beings in this unleashed state to know something about humanity… War is just such an animal thing: hunger, lice, mud, those insane noises…" Dix's lost painting, *Trenches,* done in 1923, had a palette of comparable vitality to Severini's *Red Cross Train.* Yet it showed the horrors of an actual battlefield and, in its chaotic composition, evoked the abysses of emotion the soldiers went through. Futurism was aware only of the heroic man who functioned like a battle machine.

Otto Dix, War (The Cannon), 1914

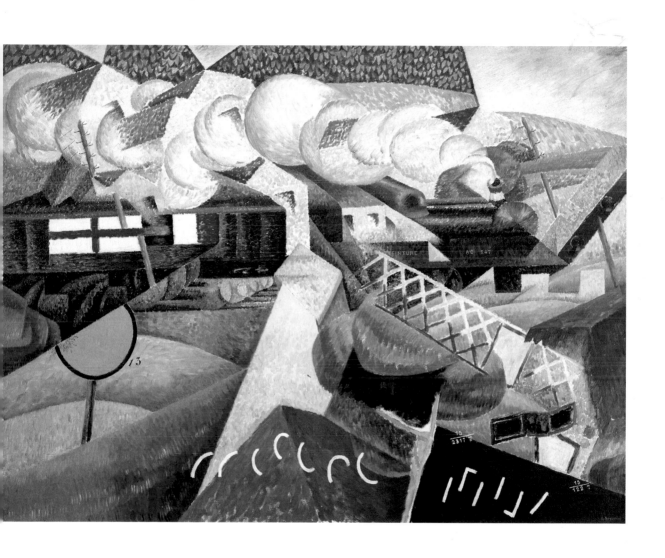

Aeroplane

Collage and tempera on paper, 72.5 x 55 cm
Private collection

* 1885 in Sassari,
† 1961 in Milan

Mario Sironi's relationship to Futurism was characterized largely by indecision. In 1908 began an involvement with the art of Umberto Boccioni that lasted for a considerable period. In 1914, sixteen of Sironi's works were included in the "Free Futurist Exhibition" mounted by the Roman dealer Giuseppe Sprovieri. Still, a year would pass until Marinetti announced Sironi's entry into the Milan Futurist group. As early as 1917–18, the influence of Pittura metafisica with its classical tendencies and dreamlike imagery began to make itself felt in Sironi's art. Nevertheless, in 1919 he was given his first one-man show at the Casa d'arte Bragaglia in Rome – one of the Futurist houses dotted around Italy which, from the end of the 1910s, propagated the movement's aims by means of a diverse cultural programme. Sironi's show, in turn, received a negative review in "Valori plastici," the key publicity organ of Metaphysical Painting.

It was in this forcefield between Futurism and Pittura metafisica that Sironi's collage *Aeroplane (Aereoplano)* emerged. It preceded a series of cityscapes done around 1920 which bore a much greater affinity to the metaphysical painting of a Giorgio de Chirico than to Futurism. These represented seemingly unpopulated urban settings rendered in gloomy colors, in which cyclists, cars, trolleys and flying objects confronted each other in often surreal ways. An oversized aeroplane, for instance, might be shown crashing beside a tiny streetcar. Some of the buildings and machines were constructed of paint and newspaper, lending them a strangely unreal look.

In his 1916 *Aeroplane,* Sironi concentrated on a depiction of that very invention. No reference to the urban setting was yet in evidence, but only a colourful interplay of painted and collaged areas. Although the artist has abstracted the motif, its legibility has been retained. Back in 1915 Sironi had already relied on the configurations of machinery to produce completely non-objective, highly coloured compositions, *composizioni futuriste.*

In *Aeroplane* he once again gave way to the euphoria of the Futurist cult of the machine. The plane is depicted rising powerfully and gracefully into the sky. Yet it reflects no reliance on the theoretical principles of Futurism which Sironi knew from his involvement with Boccioni, such as simultaneity or the notion of absolute and relative movement. Instead, the surfaces and colours are composed in an associative and playful way, characterizing Sironi as a representative of Secondo Futurismo.

Still, *Aeroplane* reflects no more than a brief excursion into the realm of late Futurism. In 1920, Sironi co-authored, with Leonardo Dudreville, Achille Funi (1890–1972) and Luigi Russolo, the manifesto "Contro tutti i ritorni in pittura" (Versus Every Return in Painting), in which a lastingly valid style and definitive form were advocated.

> **"The warmth of a piece of iron or wood has long since become more exciting for us than the smiles or tears of a woman."**
>
> F. T. Marinetti

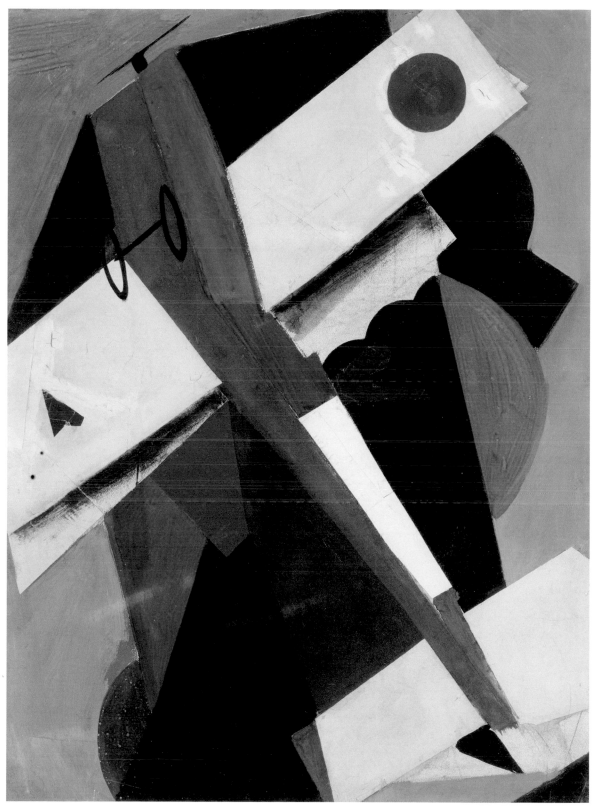

composition with "Lacerba"

Oil on canvas, 65 x 54 cm
Private collection

* 1879 in Rignano sull'Arno,
† 1964 in Forte dei Marmi

Ardengo Soffici was one of the central figures in the Florentine Futurist circles around the journals "La Voce" and "Lacerba" – two of the key publishing organs of the Italian avant-garde. Their editors took a critical stance towards Marinetti's group in Milan. Soffici worked for "La Voce" from the appearance of its first issue in 1908. This activity took him, among other places, to Paris, where he saw paintings of the Impressionists and the Cubists Picasso and Braque. In 1911 Soffici penned a devastating critique of an exhibition of Futurist painting then on view in Milan. Boccioni, Carrà and Marinetti were incensed, and met members of the magazine's editorial staff at Caffè Giubbe Rosse to have it out with them. The debate ended in physical altercations, but the storm at least served to clear the air. The Milanese and Florentine Futurists began to approach each other on an artistic level. Soffici's reconciliation with Futurism took place in the course of the year 1912, when he wrote his first decidedly positive article on the movement.

When, together with Giovanni Papini (1881–1956), he published the first issue of "Lacerba" on 1 January 1913 – both men had left "La Voce" on account of editorial tensions – a further important print medium of Futurism came into being. Carrà, Boccioni and Marinetti began working hand in hand with the "Lacerba" people, until fresh conflicts arose in 1914. Marinetti's uncompromising claims to leadership and Futurist orthodoxy poisoned the collaboration. Moreover, in this phase Papini criticized the use of materials alien to art, rejecting collage, which was just experiencing a culmination in Futurism, as "raw nature." In 1915, finally, "Lacerba" ceased publication for good.

In the atmosphere of the reawakened tensions of the year 1914, Soffici addressed the existence of the Futurist journal itself in *Composition with "Lacerba" (Composizione con "Lacerba").* The painting shows a subject that was unusual for Futurism: a still life with bottle, pear, glass, table, and the title of the journal "Lacerba." The motif appears partially fragmented, and partially recombined from geometric segments and separate elements such as pear and bottle. Stylistically, it bears more affinity with late Cubism than with Futurist works of the period. Picasso's painting *Pipe, Glass, Vieux Marc Bottle* indicates the aesthetic analogies of Soffici's work with Cubism, yet at the same time illustrates a key difference. Picasso integrated a piece of actual reality, a clipping from "Lacerba," in a synthetically composed collage. With such pasted-in, tangible textures he expanded the formal repertoire of painting.

Cubist collage technique aimed foremost at testing and varying the potentials of form. The Futurists, in contrast, consciously employed collage as a means to convey content. Soffici's *Composition with "Lacerba"* is a case in point, in that it expressly refers to the difficult situation in which the journal then found itself.

At the same time, the artist seems to have taken a cue from his friend Papini, by painting the journal's name and the paper on which it appears. That is, instead of using a fragment from reality (which he did in other paintings), Soffici abstracted from reality. The title "Lacerba" does not even appear in the typographical form usually employed by the journal. Soffici has divided the name into three parts, making it easy to draw a parallel with the conflicts in which the editors of "Lacerba" were involved.

Pablo Picasso, Pipe, Glass,
Vieux Marc Bottle, 1914

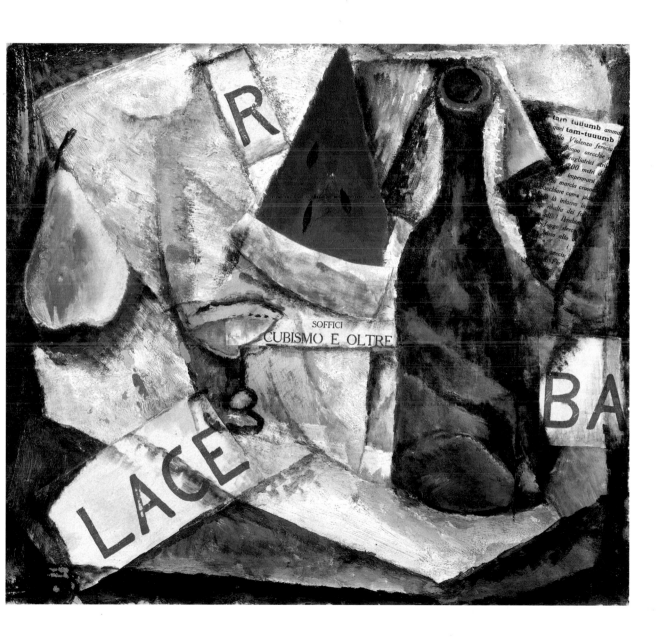

Air Battle I

Oil on cardboard, 110 x 100 cm
Private collection

*** 1910 in Igalo (Croatia),**
† 2000 in Genoa

Tullio Crali was one of the key protagonists of Aeropittura, the predominant current in Secondo Futurismo in the 1930s. He was self-taught, beginning to paint in 1925 by reference to works by Balla, Boccioni and Enrico Prampolini. When he climbed into an aeroplane for the first time three years later, the subject of flying became the focus of Crali's artistic interests. Joining the Futurist group in 1929 helped determine the direction his art would take.

Adopting the idiom of Second Futurism as defined in the 1915 manifesto "The Futurist Reconstruction of the Universe," Crali composed a first series of aerial paintings dominated by dynamic geometric curves and sweeps. These still showed flying machines from the vantage point of an outside observer who watched, fascinated, as their whirling propellors churned through the air.

Crali met Marinetti personally at the moment when he, Marinetti, published his "Manifesto of Aerial Painting" in 1931. In this pamphlet Marinetti advocated a type of painting capable of recording the changing perspectives of flight. Artists, he declared, should experience the speed of flying first hand. Then they would see the landscape below as "flattened out, artificial, provisional, as if just fallen from the sky," and as "densely compacted, scattered and dissolved, clean, magnificent."

A few of these adjectives can be applied to Crali's *Air Battle I (Battaglia aerea I)*. He had proceeded rapidly from an early, more abstract aerial painting to a naturalistic approach. Now, as Marinetti advocated, the artist actually sat in an aeroplane, and strove to create a synthesis between what he saw from a bird's-eye view and what he physically experienced and felt in the process of flying. In numerous compositions Crali evoked the way man became part of the machine, its enormous velocity, and the experience of unbounded space.

In *Air Battle I*, Crali accompanies a pilot who has taken his plane into a dive. Over the cockpit we see a cityscape that has been deformed by speed into a whirling vortex. The dynamic rotation seems to engender a centrifugal force that pushes the abstracted buildings, depicted in various perspectives, towards the edges of the picture. A reflecting water surface exerts a magical attraction, drawing the eye inexorably into the depths.

In the late 1930s, when the painting was done, Italy was preparing for imminent war. In 1936 the country had entered the Spanish Civil War on Franco's side, and in 1940 it would finally declare war on France and Great Britain.

In this phase, Crali depicted the missions flown by the Italian air force in his Aeropittura. It was typical for a representative of Futurism to glorify such operations. Just as during the First World War, Futurist artists at this point – in concord with the fascist regime – continued to apotheosize war, including what they saw as its necessary cruelties. The strange aesthetic mixture of naturalism and an abstracted idealism in a work like *Air Battle I* makes its reception today rather difficult. Transfiguration and propaganda enter an inglorious synthesis.

An opposite pole to the Futurists' world of heroic inviolability is marked by paintings like those of the German realist Franz Radziwill, in whose oeuvre the aeroplane likewise formed a constant. His works of the late 1930s and the early 1940s show the inferno of war as it was. Here, American fighter-bombers flying over a landscape scarred by craters, battle and death are omens of doom that only underscore the end-of-the-world mood that suffuses Radziwill's pictures.

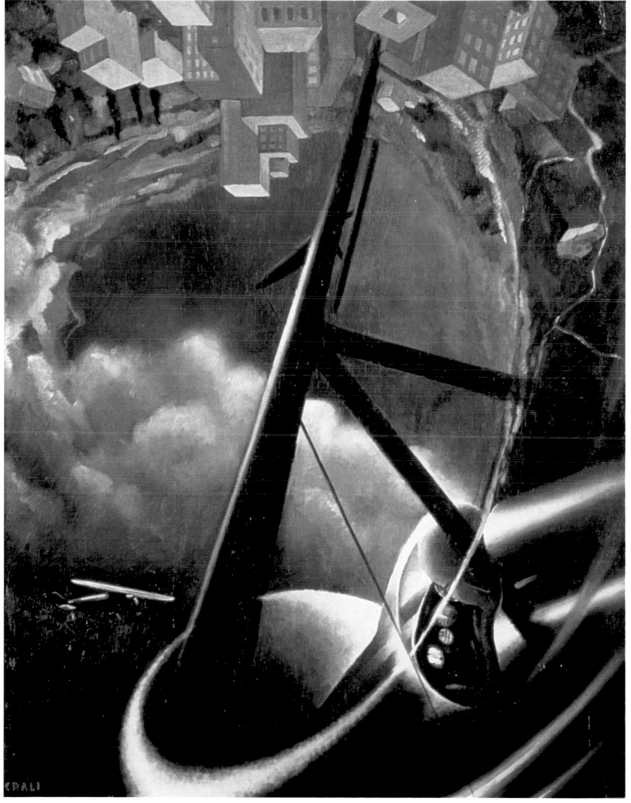

The Miracle of Light

Oil on canvas, 122 x 127 cm
Rome, Galleria Nazionale d'Arte Moderna

* 1884 in Perugia,
† 1956 in Perugia

From the 1920s, painting from a bird's-eye view was the central artistic challenge for Gerardo Dottori. He depicted many variations of this view of the earth from the air under changing dynamic and atmospheric conditions. Yet the aeroplane itself, the vantage point for such observations, was seldom included in these frequently fantastic landscape depictions. The machine cult of Futurism did not hold much appeal for Dottori, and it remains an open question whether he actually ever entered an aeroplane.

Dottori joined the Futurist movement in 1911–12, after meeting Balla in Rome. He remained true to it through every phase, and even continued to propagate Futurism beyond the end of World War II. Around 1914–15 he took up such well-known Futurist motifs as the *ciclista,* the cyclist, and around 1920 painted a series of abstract compositions, in the wake of Balla, Severini and Boccioni, who had already paved the way to abstraction in Italy during the great phase of Futurism in 1912–13.

A remarkable aspect of Dottori's oeuvre was his many murals and decorations. He concerned himself with this special variety of art throughout his lifetime. In 1934, together with Marinetti, Benedetta (Benedetta Cappa Marinetti, 1897–1977), Fortunato Depero and Bruno Munari (1907–1998), Dottori signed the "Manifesto della plastica murale," which appeared in connection with a general debate then underway over the revival of fresco painting. In Italy in the 1930s, under Mussolini's regime, such a discussion unavoidably entailed an involvement with the practice of official art.

Around the middle of the 1920s, Dottori achieved a first culmination in his Futurist depictions of the world as seen from the air. Using a splintered, dynamic vocabulary of form he evoked an intoxicating sense of speed. Strong colors, especially red and blue, embedded in a range of landscape greens, underscored the sense of rapid, energy-charged flight. His increasing mastery of this syntax led in 1926–27 to one of Dottori's major works, *Triptych of Speed.*

These three panels – devoted to the path, the journey, and the arrival – addressed the aspect of rapid motion in much the same sense, if more concretely, as Boccioni's metaphysical *States of Mind.*

In contrast, Dottori's *The Miracle of Light (Il miracolo della luce)* is concerned with a natural, atmospheric and optical occurrence. Three rainbows, depicted only in excerpt, link a cloudy, blue-violet zone of sky with a semi-abstract, slightly curving landscape vista.

The rainbow is an ancient motif in the history of art. In pre-Christian religions it was viewed as a bridge for the gods between the supernatural and natural world, and in Christianity, too, it could figure as a symbol of the divine. Subsequently, scientific explanations of the phenomenon began to enter art, most famously in the atmospheric depictions of the English painter William Turner (1775–1851).

Like many of his fellow Futurists, Dottori had begun his career with the Divisionistic technique. The division of light into the colours of the spectrum, the principle of optical mixture in the eye of the viewer, and other theoretical laws would have been familiar to him. Nevertheless, in the present composition Dottori has neither adhered to the scientifically correct sequence of rainbow colors (violet, indigo, blue, green, yellow, orange, red), nor, apparently, has he relied on any other theoretical colour system. An effect recalling the transparency and luminosity of a rainbow has been achieved solely by the use of extremely light colour gradations.

Far from the clatter and roar of Futurist machinery and unconcerned with scientific accuracy, in *The Miracle of Light* Dottori developed an approach based on intuitive abstraction.

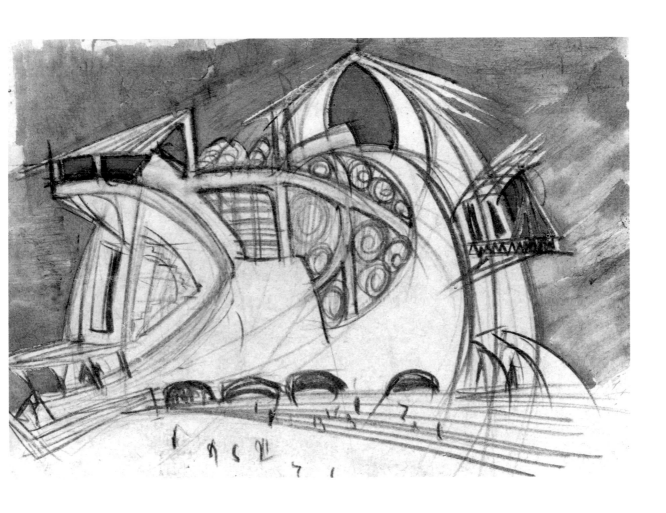

Tarantella

Oil on canvas, 80 x 80 cm
Lodz, Muzeum Sztuki

* 1894 in Modena,
† 1956 in Rome

Although there were Futurist attempts to reform the field of dance as well, they lagged far behind the innovations seen in painting, sculpture and other fields. Only Giannina Censi (1913–1995) of Milan developed, around 1930, a dance form inspired by the exhilarating sense of speed evoked in Futurist aerial painting and poetry. Yet her performances could not compare with the eurhythmics of the two American dancers Loie Fuller and Isadora Duncan, whose performances caused a sensation throughout Europe in the first years of the century.

In 1917 Marinetti published "La danza futurista" (Futurist Dance), and that same year Balla designed sets for "Feu d'artifice," a ballet to music by Igor Stravinsky, performed by the Ballets Russes in a choreography by Sergei Diaghilev. In the field of stage design and scenography, Futurism indeed developed its true creative potential. The designs of Fortunato Depero and Enrico Prampolini, which ranged from sets to lighting and costumes, put them at the forefront of a long series of Futurist productions for the dance and drama.

Prampolini wrote a manifesto titled "Scenografia e coreografia futurista" (Futurist Scenography and Choreography) in 1915, and began an activity as a stage and costume designer. By 1920, when with *Tarantella* he took up the subject of the dance in painting as well, Prampolini had entered a highly creative phase. He worked for the Teatro del Colore in Rome, and made his first trip abroad. It took him to Germany and the Weimar Bauhaus, where he met Theo van Doesburg. He also met Wassily Kandinsky, Paul Klee, Oskar Schlemmer, Piet Mondrian, and other major artists of the period who were working in a constructivist, geometric idiom. Prampolini subsequently wrote several articles for the journal "De Stijl." All of these encounters served to confirm him in his style, because from the late 1910s he had pur-

sued a geometric Futurism that was typical of Secondo Futurismo. Elements derived from the world of machinery were combined into compositions suffused with dynamism and rhythm. In the "Manifesto dell'arte meccanica futurista" (Manifesto of Mechanical Futurist Art), Prampolini joined Ivo Pannaggi (1901–1981) and Vinicio Paladini (1902–1971) to define the bases of this approach.

The tarantella is a fast, whirling dance from the Taranto region of southern Italy, composed in 3/8 or 6/8 time and accompanied by tambourines and castanets. In the course of the dance, the couples increase their speed to the point of frenzy, their rhythmical movements ending a state of ecstasy. Translated into the terms of "mechanical Futurism," human figures undergo a metamorphosis into mechanized beings, as seen in *Tarantella*. Interwoven with a stagelike background, the dancers' movements are divided into rhythmical sequences. Figures and surroundings mutually interpentrate to the staccato of the music. The geometric elements representing the arms reflect the harsh, metallic sound of castanets. The subdued colour gradations serve to tie the performance in space into the two-dimensionality of the plane. If in 1910 Henri Matisse had visualized the experience of music and dance in the different poses of a round of figures in his painting *The Dance,* ten years later Prampolini resolved both dancers and scene into a synaesthetic formal event. Various sensory stimuli – music, dance, colours, forms – merge into a single concert of mechanical rhythms.

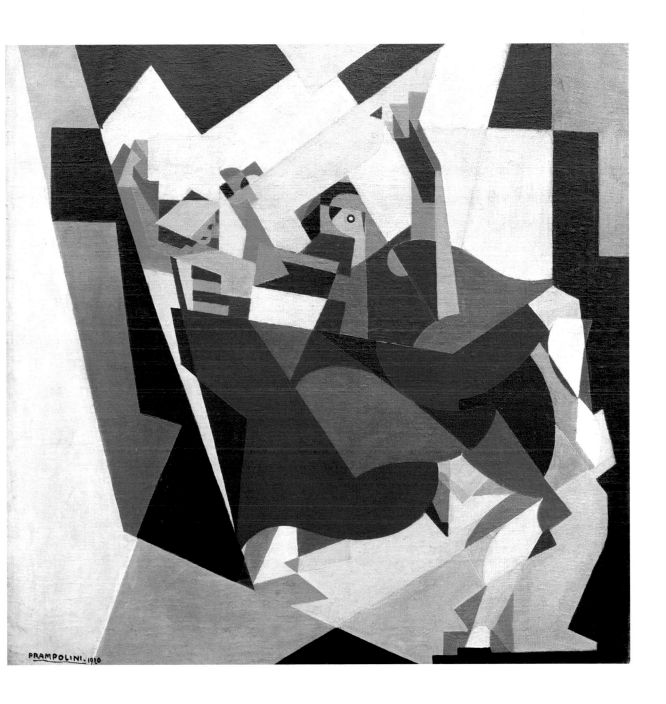

F. T. Marinetti

Collage, 50 x 50 cm
Rome, Galleria Nazionale d'Arte Moderna

Although Enrico Prampolini joined the Futurist movement in 1913, he did not become one of its major representatives until after World War I, in the phase of Secondo Futurismo. In accordance with the guidelines set forth by Balla and Depero in their 1915 manifesto "The Futurist Reconstruction of the Universe," Prampolini worked in a geometric, virtually architectural style in his paintings, collages and numerous stage set designs. In 1922 he published "The Aesthetic of the Machine and Mechanical Introspection" in the journal "De Stijl," on the occasion of the congress of avant-garde artists held in Düsseldorf that year.

Prampolini was involved in a lively exchange with the period's artists and developments in art. He had contacts with the Zurich Dada movement, with the Bauhaus, and the Sturm gallery in Berlin. From 1925 to 1937 he lived in Paris, where he joined the Cercle et Carré group and then the Abstraction-Création movement. Yet despite these diverse allegiances, Prampolini remained true to the maxims of Futurism.

In 1922 he entered a close collaboration with Marinetti. The two organized Futurist shows in Prague, Berlin and Düsseldorf, and

Pablo Picasso, Head of a Woman, 1923

Prampolini designed sets for Marinetti's play "Il Tamburo di fuoco." It is therefore probably justified to view his collage, *F. T. Marinetti,* as an homage to the founder and motor of the movement. Yet the year 1929, when the portrait was finished, was also the year in which Marinetti became an official member of the Accademia d'Italia, thus entering the traditional school system. This step amounted to an under-mining of the Futurist parameters Marinetti himself had defined and more or less radically advocated.

In his portrait Prampolini has concentrated on the head, which is rendered in semi-abstract terms. Still, the heavy, domed skull and mustache are quite characteristic of Marinetti's features. As attributes we find a few letters issuing from the writer's mouth and an aeroplane in the lower right corner. These are references to key aspects of Marinetti's concern: the Futurist renewal of language and literature, and Aeropittura, which began to come to the forefront of the Futurist aesthetic in the late 1920s. Perhaps Prampolini intended to evoke these two fields of interest in the striking division of the collage into light and dark zones. Or might he have been alluding to the two distinct phases into which the Futurist movement fell?

There is a more obvious explanation for the compact form of the head, which no longer shows much evidence of Futurist fragmentation of form. By around 1930 Prampolini had arrived at an organic style with a definite emphasis on volume. He was very familiar with the similar developments that marked Picasso's neoclassical period. "In the Holy Week of that year, 1917," Prampolini recalled in an essay of 1943, "in the room of the Hotel de Russie on Via del Babuino where he lived, Picasso, deeply moved by Raphael's visions, showed me the first neoclassical drawings he had made in the carefree and superb, obligating climate of Rome." Then he went on, "One might better describe it as a call to order, to the concrete values of an empirical world, to the acquired pictorial certainties, to appearances and the forms that result from them."

Prampolini experienced a turn away from fragmentation of form and toward a classical idiom through the person and the art of Picasso. At that same period in Italy, Giorgio de Chirico founded Pittura metafisica, or Metaphysical Painting, which likewise represented a return to order and with which some Futurists, including Carlo Carrà, allied themselves. A formal reflection of this development in Prampolini's art is already seen in *F. T. Marinetti*.

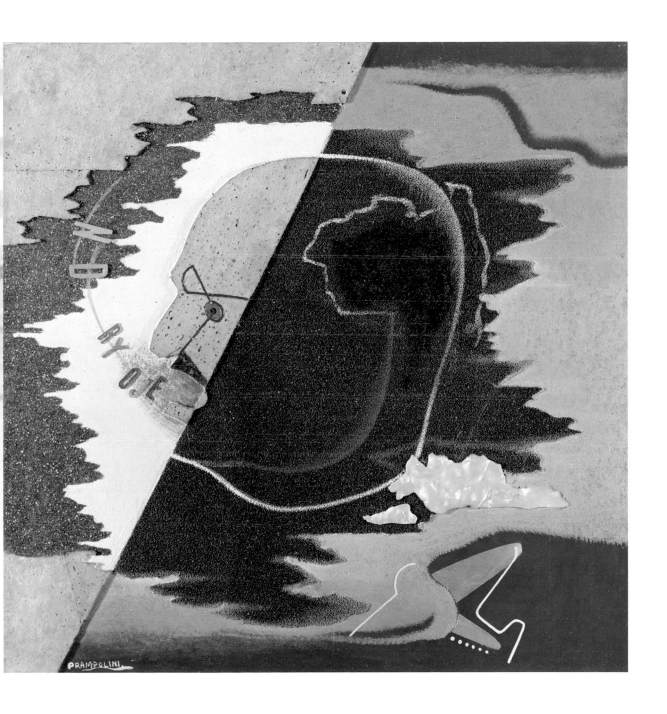

To stay informed about upcoming TASCHEN titles, please request our magazine at www.taschen.com or write to TASCHEN America, 6671 Sunset Boulevard, Suite 1508, USA–Los Angeles, CA 90028, Fax: +1-323-463.4442. We will be happy to send you a free copy of our magazine which is filled with information about all of our books.

© 2005 TASCHEN GmbH
Hohenzollernring 53, D–50672 Köln
www.taschen.com

Editorial coordination: Sabine Bleßmann, Cologne
Design: Sense/Net, Andy Disl and Birgit Reber, Cologne
Production: Ute Wachendorf, Cologne
Translation: John W. Gabriel, Worpswede

Printed in Germany
ISBN 3–8228–2966–8

Reference illustrations:
p. 26: Umberto Boccioni, *Giants and Dwarfs*, 1910, charcoal and pencil on paper, 31 x 64 cm, Turin, Galleria d'Arte Moderna, Museo Civico
p. 30: Umberto Boccioni, *The Forces of a Street*, 1911, oil on canvas, 100 x 80 cm, Basle, Private collection
p. 32: Anton Giulio Bragaglia, *Person on a Staircase*, 1911, silver gelatine print, 17 x 12 cm, Rome, Collection Antonella Vigliani Bragaglia, Centro Studi Bragaglia
p. 34: Pablo Picasso, *Young Girl with Mandoline (Fanny Tellier)*, 1910, oil on canvas, 100.3 x 73.6 cm, New York, The Museum of Modern Art, Bequest of Nelson A. Rockefeller
p. 42: Georges Seurat, *A Sunday Afternoon on the Ile de la Grande Jatte*, 1884–86, oil on canvas, 207.6 x 308 cm, Chicago, The Art Institute of Chicago, Helen Birch Bartlett Memorial Collection
p. 46: Robert Delaunay, *The Cardiff Team*, 1912–13, oil on canvas, 130 x 96.5 cm, Munich, Pinakothek der Moderne – Staatsgalerie moderner Kunst
p. 48: Umberto Boccioni, *Synthesis of Human Dynamism*, 1913, plaster, destroyed
p. 52: Giacomo Balla, Velocity of the Car, 1910, oil on canvas, no measurement given, Stockholm, Moderna Museet
p. 54: Wassily Kandinsky, *Composition VII*, 1913, oil on canvas, 200 x 300 cm, Moscow, State Tretyakov Gallery
p. 56: Edgar Degas, *Pink Dancer*, undated, pastel, 71 x 39 cm, Private collection
p. 58: Ludwig Meidner, *Self-portrait*, 1912, oil on canvas, 78.5 x 60 cm, Darmstadt, Hessisches Landesmuseum
p. 60: Erich Heckel, *The Crystal Day*, 1913, oil on canvas, 120 x 96 cm, Munich, Pinakothek der Moderne – Staatsgalerie moderner Kunst
p. 62: Giacomo Balla, *Flags on the Altar of the Fatherland*, 1915, oil on canvas, 100 x 100 cm, Rome, Galleria Nazionale d'Arte Moderna
p. 64: Giacomo Balla et al., *Futurist Life*, 1916, Film still, whereabouts of film unknown
p. 70: Giorgio de Chirico, *Hector and Andromache*, 1924–25, oil on canvas, 89.5 x 60.3 cm, Private collection
p. 72: Fortunato Depero, *Model for Pinocchietto*, 1917, painted wood, 38 x 13 x 13 cm, Private collection
p. 78: Robert Delaunay, *Circular Forms*, 1912, tempera and oil on canvas, 65 x 54 cm, Bern, Kunstmuseum
p. 80: Otto Dix, *War (The Cannon)*, 1914, oil on cardboard, 98.5 x 69.5 cm, Düsseldorf, K20 – Kunstsammlung Nordrhein-Westfalen
p. 84: Pablo Picasso, *Pipe, Glass and Vieux Marc Bottle*, 1914, pasted paper, charcoal, ink, printer's ink, graphite, gouache on canvas, 73.2 x 59.4 cm, Venice, Peggy Guggenheim Collection – The Solomon R. Guggenheim Foundation, New York
p. 90: Erich Mendelsohn, *Einstein Tower*, 1921, Potsdam
p. 94: Pablo Picasso, *Head of a Woman*, 1923, oil and sand on canvas, 46 x 38 cm, Tokyo, Bridgestone Museum of Art

page 1
F. T. MARINETTI
"Zang Tumb Tumb"
1912, cover

page 2
UMBERTO BOCCIONI
Simultaneous Visions
1911, oil on canvas, 60,5 x 60,5 cm
Wuppertal, Von der Heydt-Museum

page 4
GINO SEVERINI
Dancer = Propellor = Sea
1915, oil on canvas, 78 x 75 cm
New York, Metropolitan Museum of Art